BREWING IN
WEST SUSSEX

DAVID MUGGLETON

AMBERLEY

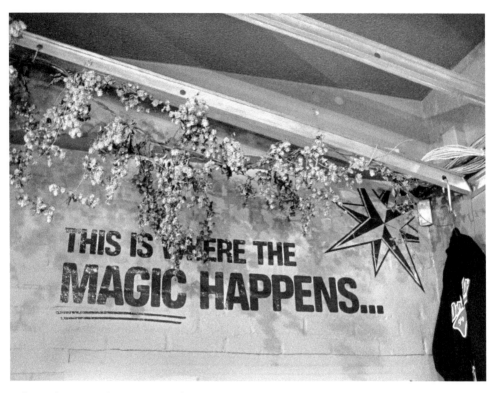

Where the magic happens: Dark Star Brewery, Partridge Green. (Author's Photograph)

Map illustration by Thomas Bohm,
User Design, Illustration and Typesetting.

First published 2017

Amberley Publishing
The Hill, Stroud
Gloucestershire, GL5 4EP

www.amberley-books.com

Copyright © David Muggleton, 2017
Maps contain Ordnance Survey data.
Crown Copyright and database right, 2017

The right of David Muggleton to be identified
as the Author of this work has been asserted in
accordance with the Copyrights, Designs and
Patents Act 1988.

ISBN 978 1 4456 5725 7 (print)
ISBN 978 1 4456 5726 4 (ebook)

British Library Cataloguing in Publication Data.
A catalogue record for this book is available from
the British Library.

Origination by Amberley Publishing.
Printed in the UK.

Contents

About the Author

Dr David Muggleton is a professional lecturer and writer with an interest in pub and brewery history. A member of the British Guild of Beer Writers, this is his second book with Amberley Publishing, the first being *Brighton Pubs*.

Acknowledgements

In addition to all those individuals, museums and breweries credited in image captions for their permission to use copyright material in this book, the author and publisher would like to thank the following for their help in sourcing such material and facilitating in any other way the writing of this book: Mike Brown and Ken Smith of the Brewery History Society; Vince Cooper, Chair of the Walberton History Group; David Harris and Graham Middleton of Emsworth, Hampshire; Jimmy Hastell of Worthing Pub History; Martin Hayes of the West Sussex County Council Library Service; Michael Mayhew of Southwold Press; Debbie Sutton of Hall & Woodhouse Brewery; Chris Tod, Curator of Steyning Museum; and my employer, The University of Chichester, for funding trips to archives and brewery sites.

An especially big thank you goes to Dale Adams and the Revd Eric Doré of the Labologists Society, who between them supplied the large majority of bottle label and beer mat images for the defunct breweries. Eric is a brewery historian, researcher and author, who would be very interested to hear from anyone who has period labels similar to those that appear in this book or from other breweries. He can be contacted by email at: eric@ericdore.plus.com.

Every attempt has been made to seek permission for copyright material used in this book. If copyright material has, however, been used inadvertently without permission then we apologise and will make the necessary correction at the first opportunity.

Foreword

By the thirteenth century, Sussex was divided vertically into six strips called rapes, originally devised for communication and defensive purposes. The pragmatic tendency to group together the three westernmost rapes for legal-political reasons was formalised in 1889, when West Sussex was created as an administrative county separate from East Sussex. West Sussex became a single ceremonial county in 1974. The use of the word 'county' in this book therefore refers specifically to West Sussex. Its population of c. 809,000 is concentrated in three major settlements: along the south coast; in the mid-Sussex M23/A23 corridor; and in the north, where the town of Crawley is the largest in the county. Although its area of 769 square miles remains largely rural, with

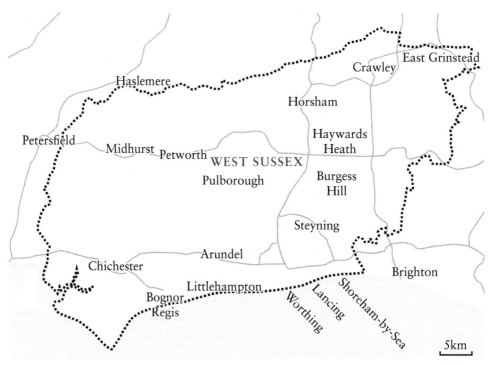

much protected countryside, less than 2 per cent of today's inhabitants are employed in agriculture. Nearly 80 per cent of the county's gross wealth is produced by the service sector, the remainder by light industry. The geographical organisation of chapters in this book is based on a widely recognised topographical approach that identifies character guidelines for local landscape distinctiveness, but tempered with a dose of pragmatism.

The first chapter begins in Chichester and takes in the underlying Coastal Plain, but allocates the coastal towns to the second chapter. Although the South Downs and the Western Weald have markedly different natural characteristics, they are combined in the third chapter as comprising part of the South Downs National Park. The fourth chapter moves across the Low Wealden clay plain to take in the towns and large villages of mid-Sussex. The Forest Ridge of the High Weald is the subject of the fifth and final chapter. When additionally considering the route taken within chapters, the reader is led through the course of the book from the south to the north of the county by traversing it from west to east and east to west twice over. One further geographical feature that emerges from the book is that the county brewers of the past were concentrated in the town centres, whereas the new generation has emerged mostly in villages or on light-industrial estates. This is an example of the late-twentieth-century process of delocalisation, the redistribution of retail production and consumption units from the urban central zone to the suburban and rural periphery.

David Muggleton
Bognor Regis,
4 October 2016

Introduction

While this book is intended to appeal to those who are well acquainted with beer and brewing, it is equally aimed at the reader with a cursory knowledge of the subject but a keen interest in local history. Technical terms are therefore kept to a minimum and explained at their first appearance in the text. Although the book makes reference to all recent West Sussex breweries and includes many past major concerns, its historical sweep is nevertheless selective rather than exhaustive. Its overriding purpose is to view the past through the prism of the present so as to illuminate three main issues: first, a relatively recent growth in small independent breweries, a phenomenon known as 'the microbrewery revolution', has provided an unpredicted countermovement to the trend towards concentration and centralisation of the industry following a process of amalgamation and acquisition during the nineteenth and twentieth centuries; second, that the microbreweries have not eschewed but have embraced the heritage of the old brewers, albeit in a way that is progressive; third, that microbreweries are defined as much by ethos as size and that this has required a realignment of market relationships, between a new type of artisan producer and a more affluent, product-aware consumer.

The practice of brewing beer from grain originated in Mesopotamia – an area encompassing modern-day Iraq – possibly as early as 8000 BC, and certainly by 4000 BC. Beer drinking was also popular in Ancient Egypt. The first brewers and farmers may have made their way to these shores by the Neolithic period, *c.* 4500–3000 BC. Alternatively, the Beaker Folk of *c.* 2000 BC may have introduced brewing to the British Isles. Either way, by the time of the Roman invasion of the first century AD, the Celtic Britons had established a prolific brewing culture. Some of the wine-loving Roman legions were even converted to drinking ale, a point worth remembering if visiting the two excavated Roman sites in West Sussex: the palace at Fishbourne and the villa at Bignor. It is, however, the arrival of the Jutes, Angles and Saxons from the fifth century AD that more firmly establishes the locality of our narrative, for the name 'Sussex' derives from the Old English '*Suthseaxe*', meaning 'South Saxons'. The Anglo-Saxons created a communal drinking culture centred on the alehouse. Brewing was then mostly a domestic enterprise, and those who offered their produce for sale projected an ale-stake or ale-pole, adorned with a garland, outside their home – a forerunner of the pub sign.

The Norman Conquest of Britain, a process originating in Sussex, did not dent the popularity of ale drinking and even raised the standards of brewing, although the product bore little resemblance to the beer of today: whether fresh or stale, sweet or sour, cloudy or clarified, flavoured with honey, herbs or spices, it did not use the preservative and bittering agent called hops and was hence termed ale. The first hopped beer to be shipped to England, possibly from Holland, supposedly arrived at Winchelsea (another first for Sussex) in 1400, while the oldest surviving English brewing recipe involving hops dates from 1503. Beer brewing certainly took place in England between these two dates but, because hops came from the Protestant Low Countries, their use in the pre-Reformation era was perceived as unpatriotic. The most famous eulogising of ale and diatribe against hopped beer was by Sussex-born Andrew Boorde (1490–1549). This sometime monk and physician became renowned for his witty repartee when selling his medicines at country fairs; the current Adur Brewery named their Merry Andrew strong ale after him, although the 'ale' in question is actually a beer. By 1602, when brewer Henry Stanton was indicted for petty larceny in Crawley, the nutmeg and cinnamon he was accused of stealing was very likely intended to flavour beer and not ale.

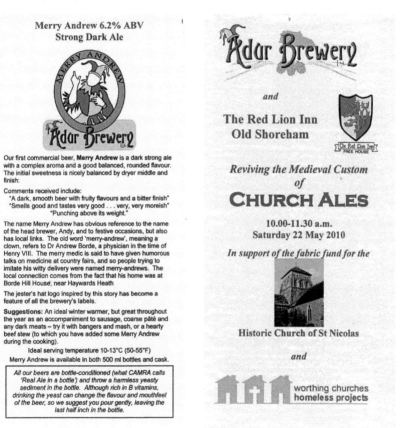

Above left: A local jester: Adur Brewery Merry Andrew. (Author's Collection)

Above right: Reviving the custom of church ales. (Author's Collection)

As a former Carthusian monk, 'Merry Andrew' Boorde would have been familiar with the monastic tradition of brewing, one brought to a halt with the Dissolution of the Monasteries by Henry VIII in the mid-sixteenth century. Another religious custom involving brewing – eventually suppressed by the Puritan Protestants in the seventeenth century – was that of church ales. These were local festivals held in a church house, where specially brewed ale was sold to raise funds for the parish. Our aforementioned Adur Brewery revived this tradition of church ales and was itself launched at one such event. With the demise of the religious domain, a greater proportion of beer was supplied by retail brewing victuallers (the tavern, inn or alehouse with its own brewhouse). In the medieval period these were mostly run by women, technically known as brewsters but colloquially referred to as 'alewives'. Popular consciousness constructed a picture of the alewife as a drunken, detestable old harridan, mainly because such women became a scapegoat for the selling of short measure and the production of poor-quality ale. Men had come to dominate this sector by 1743, when widow Mary Cooper ran a cottage-industry brewhouse in Midhurst. Her probate inventory of that year included six barrels of beer valued at £2.

Although common (commercial wholesale) brewers existed before the eighteenth century, their numbers and market power began to swell rapidly with the onset of industrial capitalism fuelled by an entrepreneurial Protestant work ethic. While the number of brewing victuallers in England and Wales fell in the years 1700–99 from 39,469 to 23,690, the number of common brewers rose in the same period from 746 to 1,382. By 1870 they totalled 2,512. This was an era of unprecedented technological development, with a range of factors leading to greater economies of scale. Steam power was harnessed, with at least three breweries in West Sussex proclaiming the use of this invention in their names. Transportation systems improved (Sussex roads were reputed to have once been the worst in England) and the coming of the railway hastened the urbanisation of the county towns, particularly along the tourist coastal area, creating dense local markets and more public house outlets to supply. Brewing science led to improved beer quality, while temperature control enabled all-year-round brewing. By the late nineteenth century, the famous family brewing firms of the county – the Kings and the Barnes of Horsham, the Hentys of Chichester, the Ockendens of Crawley, the Constables of Arundel and Littlehampton – were fully established.

The number of common brewers began to fall from this point onwards, although the remaining firms became larger, with increased average output. West Sussex saw a sizable proportion of its brewing victuallers disappear during the 1850s and 1860s, some of which had been created in the wake of the 1830 Wellington Beer House Act, while the greatest loss of its common brewers occurred in the 1880s and 1890s, with many breweries subject to mergers and takeovers. Another seventeen West Sussex breweries succumbed during the first quarter of the twentieth century. Three more casualties in the 1930s and 1940s left just two survivors, both of which had been formed through mergers: Henty & Constable of Chichester was eventually sold in 1955, leaving King & Barnes of Horsham as the county's sole brewing concern. The local pattern was a reflection of the national trend towards concentration of capital in the industry. The number of common brewers in the UK fell by 44 per cent in the

Steam powered: Egremont Steam Brewery. (Harrod & Co.'s Directory, 1867)

Family Pale Ales: King & Son, Horsham. (Kelly's Directory, 1887)

George Ockenden & Son, Crawley. (Pike's Blue Book, 1899)

ANCHOR BREWERY, LITTLE HAMPTON.

THOMAS CONSTABLE,

PALE ALE AND PORTER BREWER,

SPIRIT MERCHANT.

Families supplied with superior Ales and Stout in Casks or Bottles.

Pale Ale and Porter Brewer: Thomas Constable, Littlehampton. (Melville & Co.'s Directory, 1858)

TELEPHONE: CHICHESTER 85

HENTY & CONSTABLE Ltd.

Branches at
ARUNDEL, Tel. 99
LITTLEHAMPTON, Tel. 122
WORTHING
and
EMSWORTH, Tel. 6

MANUFACTURERS OF
CELEBRATED
ALES
& MINERAL
WATERS

HEAD OFFICES:
WESTGATE BREWERY,
CHICHESTER.

Henty & Constable, Westgate Brewery, Chichester. (Kelly's Directory, 1934)

Telephone: Horsham 118

KING AND BARNES L^{TD}

THE HORSHAM BREWERY
Head Office: 15 CARFAX, HORSHAM

CELEBRATED
HORSHAM
ALES & STOUT
in cask and bottle
WINES, SPIRITS AND
MINERAL WATERS

King & Barnes, Horsham Brewery. (Kelly's Directory, 1938)

years 1880–1914; a 75 per cent loss was recorded from 1915–1939, with a further drop of over 50 per cent from 1940–1960. By the end of the 1960s, six vertically integrated national companies dominated the UK brewing industry. In 1989, the 'Big Six', as they were known, produced 75 per cent of UK beer output and owned 75 per cent of tied pubs.

Yet when the much-loved family firm of King & Barnes closed in 2000, this left West Sussex with no less than four small independent breweries, while another seven

Ballard's Brewery, Nyewood.
(Courtesy of John Law)

had opened and closed in the two previous decades. The first wave of microbreweries had made their unexpected debut in the 1970s. Many revived the tradition of the brewpub; others were founded on farms or located on out-of-town industrial estates. At the time of writing, there are nearly thirty known breweries in the county, virtually all of which are small concerns, the oldest being Ballard's, formed in 1980. Their rate of growth slowed in the 1990s due to tough trading conditions. It picked up slightly in the decade from 2000 but the last seven years have seen a second wave of twenty-one West Sussex independents created, with only four closing since 2002. This is in line with the national situation, where the number of UK breweries (currently 1,540) is the highest it has been for some seventy years. To explain this success we have to realise that the microbreweries have been spawned from very different social conditions to those that gave rise to the market monopoly of the 'Big Six'.

Even well into the twentieth century, beer was an integral part of the staple diet of the agricultural labourer and factory worker. In our new-millennium, post-industrial consumer society, beer drinking is an increasingly expensive lifestyle choice in a highly segmented market. Many second-wave microbreweries have accordingly adopted a new promotional discourse of 'artisan' or 'craft' production, one that holds out the reassurance of tradition with the beguiling promise of cutting-edge development. Whereas the national brewers had largely promoted keg beer (chilled, filtered and pasteurised), the microbreweries returned to real ale (beer undergoing secondary fermentation in cask or bottle) and in the process have revisited the recipes for past beer styles, recreating stouts, porters and strong milds. This has rekindled a passion for a local identification – as reflected in the names of some breweries and their beers – that had been eroded by the market reach of the nationals. Yet microbreweries are also progressive, with a portfolio that may include organic or vegan beers, golden beers flavoured with high alpha New World hops, and a range of 'craft keg' beers, served chilled and pressure-carbonated to suit the palate of younger drinkers. When considering today's healthy respect for our brewing heritage alongside the innovative range of beer styles available, it can convincingly be argued that there has never been a more creative period for brewing or a more exciting time for beer drinking.

A Victorian-style strong mild.
(Courtesy of Gary Lucas)

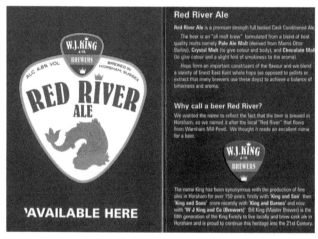

Beer named after a
local river. (Courtesy of
Bill King)

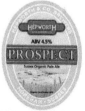

New Beer, Old Style, Organic Prospect. (Courtesy of
Hepworth & Co.)

Chichester and the Coastal Plain

The county town of Chichester is also the county's only city. The spire of the cathedral – the See was obtained in 1075 – appears as a prominent landmark from the underlying belt of low-level flatlands known as the Coastal Plain. Arable farming and market gardening characterise the fertile, open landscape, but much coastline has been taken up by twentieth-century housing development.

Chichester

Although once possessed of a flourishing Georgian brewing industry, Chichester has been bereft of brewing since the loss of the Westgate Brewery of Henty & Constable in 1955. Probably founded in 1751 (the old brewery offices bear this date), the business was first acquired by the Henty family in 1830. Henty & Sons amalgamated with the Constables of Arundel and Littlehampton in 1921. The initials 'RIH' on the letterhead image are those of the company's last MD, Richard Iltid Henty, who died on a cruise ship recuperative voyage in 1954, aged just fifty-one. The assets were sold to raise money for the death duties, with the tied-house estate split between Tamplins of Brighton (who were being taken over by Watneys of London) and Friary, Holroyd & Healey of Guildford. The pubs were ranked according to barrelage and a pack of cards was famously cut to decide first choice.

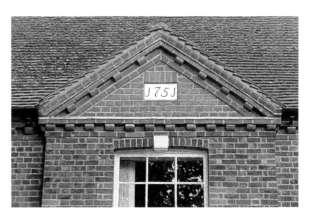

Founded in 1751: the former Westgate Brewery offices. (Author's Photograph)

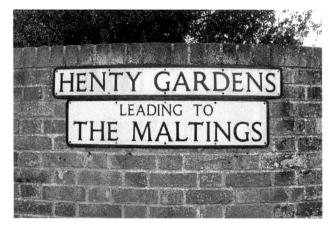

Henty Gardens, Chichester. (Author's Photograph)

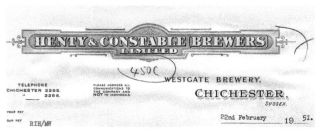

Initials 'RIH' on a Henty & Constable letterhead. (Brewery History Society Archive)

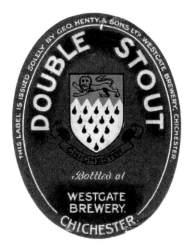

Double Stout: Henty & Sons bottle label. (Courtesy of the Eric Doré Collection)

The South Street Brewery was in existence by 1755 and was operated by George Gatehouse senior from *c*. 1815. Richard Covey Gatehouse took over at his father's death in 1847. His son George continued the business from 1874 until 1889, when he sold the brewery and its thirty-three pubs to the Westgate Brewery.

The East Walls Brewery was built *c*. 1779 and by 1832 was run by the Atkey family. When James William Atkey died in 1865, his brother Charles continued the brewery until 1880 when it was purchased by the partnership of Royds & Marsden. They sold it with its twenty-two pubs in 1889 to Lambert & Norris of Arundel. The site was auctioned off and redeveloped as the Shippams paste factory.

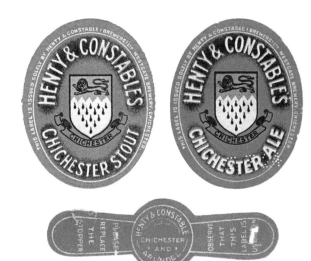

Henty & Constable bottle labels. (Courtesy of the Eric Doré Collection)

Henty & Constable drip mat. (Courtesy of Martin David)

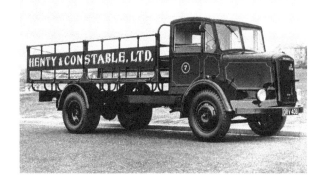

Henty & Constable motorised dray. (Brewery History Society Archive)

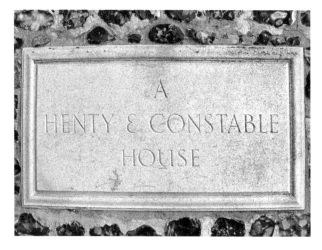

Henty & Constable plaque
at the Fox Inn, Felpham.
(Author's Photograph)

RICHARD GATEHOUSE,

BREWER, MALTSTER,

AND

SPIRIT MERCHANT,

CHICHESTER.

Bitter and Pale Ales in Small Casks for
Families.

BOTTLED PALE ALE & STOUT.

Richard Gatehouse, South
Street Brewery. (Melville &
Co.'s Directory, 1858)

JAMES WILLIAM ATKEY,

BREWER & MALTSTER,

AGENT FOR MEUX'S LONDON STOUT,

EAST WALLS,

CHICHESTER.

James William Atkey, East Walls Brewery. (Melville & Co.'s Directory, 1858)

The North End Brewery may have been built by the Gatehouse family *c.* 1815. It is advertised in 1858 under the name of Henry Harmsworth, who was also a publican brewer. The 1851 census lists him as a Master Brewer living at 4 Old Broyle Road, with his wife, Ann, their four children and a general servant.

There are visible remains of three breweries that once operated from outhouses behind pubs. The Purchase family developed the Globe Brewery at the Globe Inn, South Street, from 1836. The single-storey brewhouse is now a garage. The 2016 renaming of the pub as the Foundry was apt, for one previously stood on the site. The Wooldridge family established the Eastgate Brewery *c.* 1811 in The Hornet, behind the still-trading

NORTH END BREWERY.

H. HARMSWORTH,

BREWER AND BEER

RETAILER,

STOKE ROAD, CHICHESTER.

Henry Harmsworth, North End Brewery. (Melville & Co.'s Directory, 1858)

Globe Inn, Chichester. (Author's Photograph)

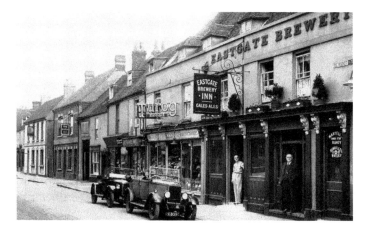

Eastgate Brewery Inn, Chichester, 1920s. (Brewery History Society Archive)

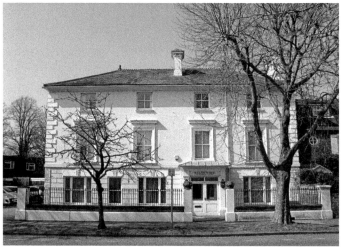

The former Victoria Inn, Chichester. (Author's Photograph)

Eastgate Inn. Brewing ceased when it was purchased in 1879 from John Goldring by Gales of Horndean. The brewery building is now a games room. The Deller family ran the Victoria Brewery, St Pancras, from *c.* 1830 but there was a brewhouse on the site by 1744, predating the now-closed Victoria Inn. Brewing may have ceased by 1905. The brewhouse and cellar are now offices and a restaurant.

Hermitage

In November 1981, the five-barrel plant of the Hermitage Brewery was installed in the old tower brewhouse at the Sussex Brewery Inn by Ray Drewett, Dave Underwood and Roy Stevens. (The number of barrels denotes the size of the brewing plant, one brewer's barrel being 36 gallons.) After new owner Malcolm Roberts arrived in 1985, the enterprise was renamed the Sussex Brewery and the former Hermitage Bitter called Wyndhams Bitter in memory of former landlord-owner, Edward Wyndham Miller, whose name still appears above the door of the inn. The Miller family had held the property for generations and brewed there using their own well source until *c.* 1890. The new brewery ceased production in 1991.

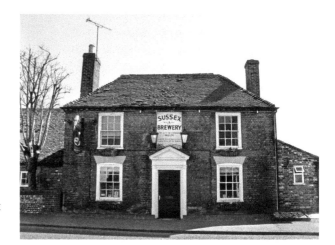

Remembering Edward Wyndham Miller: the Sussex Brewery Inn, Hermitage. (Author's Photograph)

Hermitage Brewery beer mats. (Courtesy of Dale Adams)

Chidham

In December 1979, landlord and ex-army officer Ernest Scott and brewer John McBride established the Old Chidham Brewery behind the Old House at Home pub in Cot Lane. It appears to have been the county's first brewpub since the 1940s. As with most of the first wave of microbreweries, the beer range was solidly traditional, consisting of a session, best and premium bitter plus a strong, dark winter brew, although two commemorative bottled beers were also produced. The brewery was dissolved in July 1983, owing money to the excise.

Old Chidham Bitter window sticker. (Courtesy of Dale Adams)

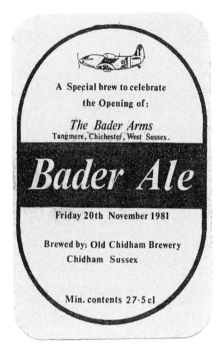

Old Chidham Brewery bottle label.
(Courtesy of Dale Adams)

Bosham

Philip Turnbull began the Bosham Brewery in March 1984 on a self-built plant at his father's garden centre in Walton Lane. Production of a traditional range of beers increased from 50 to 500 gallons a week until brewing ceased in late 1986, when Philip decided to focus fully on horticulture. The plant was purchased in March 1987 by Peter Hague and Paul Tanser, owner and landlord respectively of the Gribble Inn, Oving.

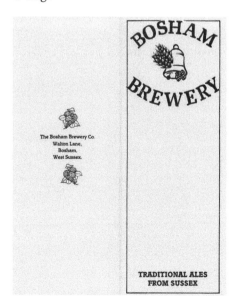

Bosham Brewery brochure.
(Courtesy of Dale Adams)

Oving

The Gribble Brewery commenced in Oving at Madam Green Farm following the aforementioned purchase, with the beers initially marketed under the Bosham label. Brewing ceased in 1989, but resumed two years later at the Gribble Inn when the new leaseholders (from May 1988), Dorset brewers Hall & Woodhouse, installed a new five-barrel plant in the outbuildings, allowing it to be run as an autonomous concern. The brewery became fully independent in 2005. It is named after local schoolteacher Rose Gribble, who used to live in the cottage that became the Gribble Inn in March 1980.

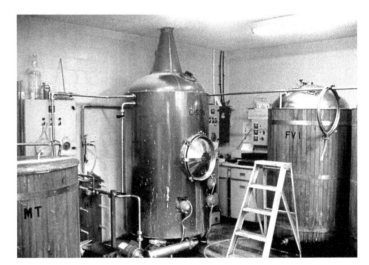

Gribble Brewery plant. (Courtesy of John Law)

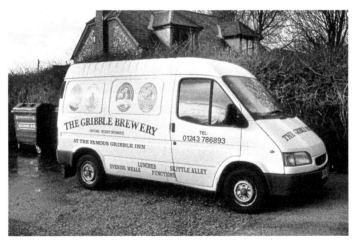

Gribble Brewery van. (Courtesy of John Law)

Lagness

The use of scientific analysis to convince the public of the health-giving properties of a brewer's beer was a common component of Victorian adverts, as can be seen from the 1867 example of the Lagness Brewery near Pagham. George Collins is listed as brewer from 1845 to 1881.

LAGNESS BREWERY,
PAGHAM, NEAR CHICHESTER.

◇ **GEORGE COLLINS,** ⚒
BREWER,

Respectfully informs his Friends and the Public, that having had the Water with which he Brews his Ales and Beer analyzed, it has been found to possess those mineral qualities which are so highly salutary and beneficial; he therefore confidently offers his ALES and BEER for their approbation, and earnestly solicits their patronage.

MEUX'S LONDON STOUT.

Highly salutary and beneficial: Lagness Brewery. (Harrod & Co.'s Directory, 1867)

Walberton

The Walberton Brewery was first recorded in 1828 under the ownership of William Ellis. After the death of Edward Ellis in 1869, it was run by his wife, Matilda, a rare example of a Victorian brewster. Her son, Michael, continued the business after her death in 1903. Brewing ceased by 1922, when the five-quarter brewery and its four pubs were acquired at auction for £6,700 by the Rock Brewery of Brighton.

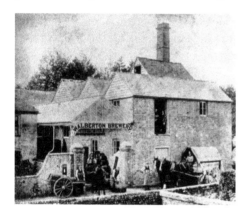

Walberton Brewery. (Courtesy of Brenda Dixon)

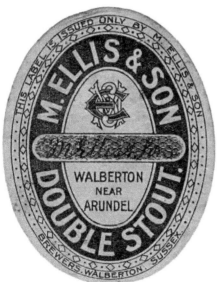

Double Stout: Walberton Brewery bottle label. (Courtesy of the Eric Doré collection)

Ford

It was a magnificent achievement for a new microbrewery to triumph at such a venerable competition when Arundel Brewery won a gold medal at the 2004 International Brewing Awards with Sussex Mild. The dark brown, lightly hopped beer had a session strength of 3.7 per cent (a measurement of the percentage of alcohol by overall volume). It was a recreation of a style tremendously popular during the mid-twentieth century but which had since become endangered. The brewery was founded in November 1992 at Ford Airfield, the first in the county on an industrial estate. Three changes of ownership have overseen much expansion. A beer club was launched in September 2013 and a brewery shop opened in July 2014 at River Road in Arundel.

In December 2012, the Little Coffee House & Bistro in Littlehampton began selling bottle-conditioned Lister's Ale, a traditional English session bitter brewed on the premises by Philip Waite, son of the family owners. Philip, a cook and self-taught brewer with an art college and City oil-trading background, also built the fully automated 0.25-barrel kit and bottle-filler. Philip moved Lister's Brewery to The Old Dairy, Ford Lane, in late 2014, installing a new five-barrel plant. A range of cask ales is now produced. It is named after the family terrier, now alas departed to the great kennel in the sky but immortalised in the brewery artwork.

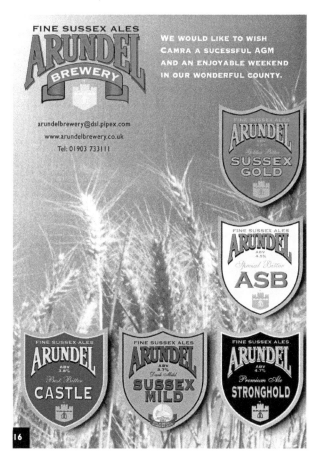

Fine Sussex Ales: Arundel Brewery advertisement. (Courtesy of Arundel Brewery)

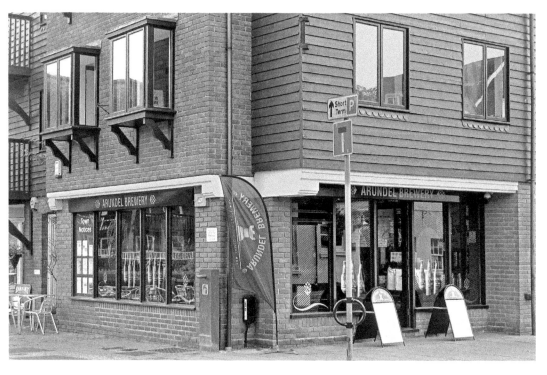

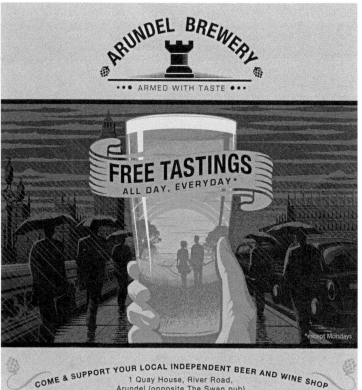

Above: Arundel Brewery shop. (Author's Photograph)

Left: Arundel Brewery shop brochure. (Author's Collection)

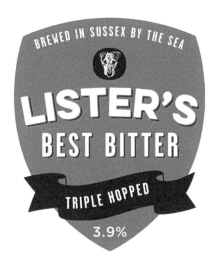

Lister's Best Bitter pump clip. (Courtesy of Philip Waite)

Lister's brewer Philip Waite enjoying his own beer with the author. (Author's Photograph)

Poling

Named after a neighbouring hamlet, Hammerpot Brewery was founded at The Vinery by Lee Mitchell and Frank Phillips. Their first two beers – Meteor, produced on 10 August 2005, and Red Hunter – commemorated the Gloster Meteor and Hawker Hunter jets, each of which held the world air speed record over the sea at nearby Rustington, in 1946 and 1953 respectively. Bottle Wreck Porter was first brewed in 2007. Recalling a ship that was wrecked off the Sussex coast and found to be carrying bottles of porter – a style enormously popular in the eighteenth century – this dark beer went on to win a gold medal at the 2012 CAMRA (Campaign for Real Ale) National Winter Ales Festival.

Rock musician and home brewer Mark Lehmann certainly has the Midas touch. Of all the recipes he developed on his pilot plant, Liquid Gold was the first to debut and bring great acclaim. Goldmark Craft Beers opened at The Vinery in April 2013 with an eleven-barrel capacity. German-born Mark grew up in the UK, leaving him with a love for both Continental *biers* and English ales. This is reflected in his duo range of craft keg and cask-conditioned beers.

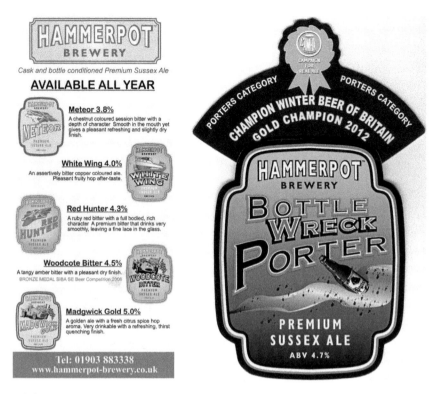

Above left: Premium Sussex Ales: Hammerpot Brewery leaflet. (Author's Collection)

Above right: Award-winning beer: Hammerpot Bottle Wreck Porter pump clip. (Courtesy of Dave White)

Above left: Hammerpot Brewery anniversary beer mat. (Author's Collection)

Above right: Goldmark Craft Beers Liquid Gold pump clip. (Courtesy of Mark Lehmann)

The Coastal Towns

Bognor and Worthing were both fishing villages until the eighteenth century, when separate attempts were made to develop them as elegant and fashionable resorts. It is fair to say that Worthing fared the better of the two. Littlehampton and Shoreham-by-Sea both originated as ancient ports. All four towns (along with the smaller settlements of Lancing and Southwick) urbanised rapidly from the mid-nineteenth century with the arrival of the railway. Tourism and harbourside development respectively characterise these two pairs of towns today.

Bognor Regis

The Upper Bognor Brewery was established from 1810 in Brewery Lane by the Turner brothers. It was sold in 1880 by Richard Talmy Turner to brothers Charles and Frederick Gibbons, who were partly financed by a loan of £1,300 from their father. Frederick soon sold his share to his brother – a wise move, since Charles lacked business acumen. Debts of £4,300 had amounted by the time of a creditor's meeting in November 1893. Mr Gibbons senior was reimbursed only £300 of his original loan and he was one of the luckier ones.

The town once had a number of publican brewers. Timothy Tomsett was active during the 1840s and 1850s, first at the Anchor Inn, then the Coach & Horses; both pubs were demolished in the 1970s. The Lion Brewery of Edward Pacy was at the Waterloo Inn from 1855–62. The Victoria Brewery was adjacent to the Victoria Inn, Charlwood Street; the pub and brewery were owned by Richard Allen from 1866 until his death in 1891.

BOGNOR-ON-SEA, SUSSEX.
R. TALMY TURNER,
BREWER, MALTSTER, & SPIRIT MERCHANT
VERY SUPERIOR FRENCH AND ENGLISH CORDIALS.

Terms, Cash or Reference. The Trade Supplied.

Richard Talmy Turner, Bognor-on-Sea. (Kelly's Directory, 1870)

Dinner Ales: Gibbons brothers of Bognor. (Deacon's Court Guide, 1881)

Ernest Pacy, Lion Brewery, Bognor. (Melville & Co.'s Directory, 1858)

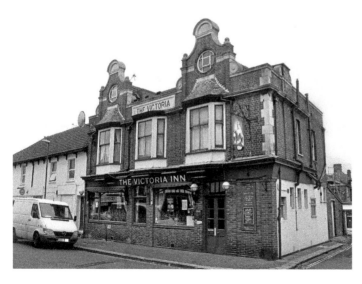

Victoria Inn, Bognor Regis. (Author's Photograph)

Littlehampton

The Anchor Springs Brewery commenced in May 2010 and three years later won a gold medal at the SIBA (Society of Independent Brewers) South East Regional Beer Competition with Mothers Ruin. This 6.0 per cent premium beer was brewed by Will Jenkins, son of the brewery owner, businessman Kevin Jenkins. In 2015, Kevin moved the five-barrel plant from the Lineside Industrial Estate to the newly refurbished Tap & Barrel brewpub in Duke Street, changing the brewery name to the Littlehampton Brewery. The original name had recalled the Anchor Brewery that was run by Constable & Sons until 1917, when beer production was switched to their Arundel site. The brewery buildings became a plant for a brand of table waters called Anchor Spring.

The aforementioned Anchor Brewery was established in the High Street by James Corfe in 1816 and by 1839 was in the hands of George Constable. The Constables were connected by marriage to George Bowden Puttock, who ran the brewery for a decade until 1860. George's son Thomas had the brewery rebuilt in 1871 and continued to run it until his death in 1883. It passed down the family line to the final owner, Archibald Constable, who had founded the town's cricket club and served on the Urban District Council. The Constables merged in 1921 with the Hentys of Chichester. Most of the brewery was demolished in 1972, with the remainder incorporated into shop fronts.

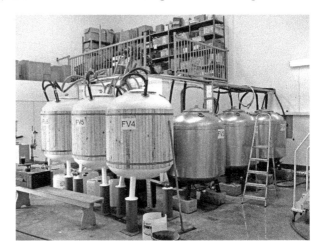

Anchor Springs Brewery.
(Author's Photograph)

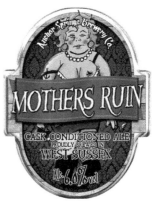

Award-winning beer: Anchor Springs Mothers Ruin
pump clip. (Author's Collection)

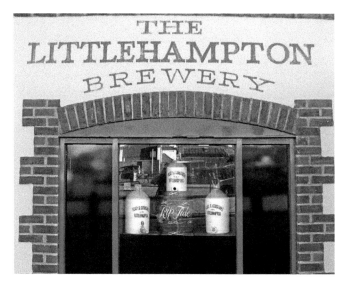

Littlehampton Brewery.
(Author's Photograph)

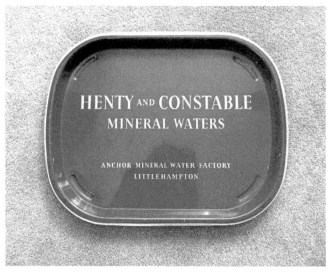

Anchor Mineral Water
Factory tray. (Courtesy of
Chris Austin)

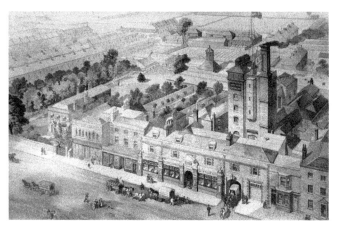

Anchor Brewery,
Littlehampton.
(Courtesy of
Littlehampton Museum)

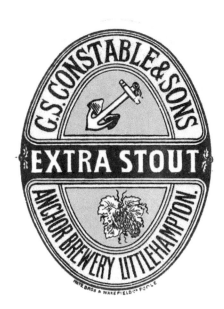

Extra Stout: Constable & Sons bottle label.
(Courtesy of the Eric Doré collection)

Worthing

Alan Mearns had plans to relocate his recently established Old Prentonian Brewing Co. to pub premises in the town, but the move did not materialise and he continues to operate in nearby Sompting. Alehouse & Kitchen remains the only brewery in Worthing: the in-house plant at this High Street pub-restaurant first brewed in March 2015. The largest proportion of Worthing's past breweries by far also appears to have been associated with pubs and beerhouses.

The Slug & Lettuce in Chapel Road has gone through a number of names in recent years but was for most of its existence called The Fountain. As the Fathom & Firkin, it had its own brewkit from 1997–99. All fifty-four of these Firkin Breweries of the Allied-Domecq pub estate were closed after a takeover by Punch Taverns. The Fountain Brewery of the Carters was attached to the original Fountain pub, adjacent to the present building. It was in operation from 1823–89 and purchased at auction in 1892 for £4,200 by Nalder & Collyer of Croydon.

From 1836–67, William Slaughter was running the Warwick Brewery in Ann Street – abutting the rear of the Warwick Arms at 11 Warwick Street – and sending dinner and supper beer to any part of the town at the shortest notice. He was succeeded by his son, John. The brewery was founded c. 1832 by John Farmer and continued until at least 1891.

Both the Egremont Hotel (subsequently pub) and Brewery were built in Warwick Road in 1835 by George Greenfield. He was succeeded by Walter Greenfield, whose advertisement for his 'celebrated Worthing pale ales' claimed that the brewery had been founded in 1820. It was acquired in 1880 by Harry Chapman, who renamed it the Tower Brewery and expanded trade considerably, before selling to Ernest Adams in 1920. Brewing ceased in 1924 after pub and brewery were acquired by the Kemp Town Brewery of Brighton.

The Montague Brewery (and possibly its associated beerhouse) was founded in Montague Street by 1843. It was acquired in 1862 by Jacob Searle, a somewhat enigmatic character. Born in the town in 1826, Searle was a humble fisherman who

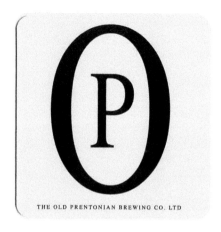

Old Prentionian beer mat. (Author's Collection)

Alehouse & Kitchen, Worthing.
(Author's Photograph)

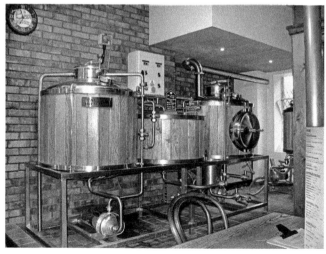

Alehouse &
Kitchen plant.
(Author's Photograph)

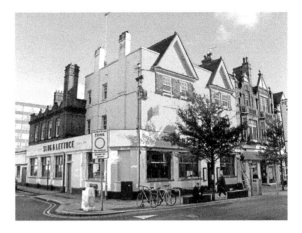

The former Fountain Inn, also once the Fathom & Firkin. (Author's Photograph)

William Slaughter, Warwick Brewery. (Harrod & Co.'s Directory, 1867)

WARWICK BREWERY.

W. SLAUGHTER,

Brewer and Spirit Merchant,

ANN STREET, WORTHING.

Orders received at 11, Warwick Street, and at the Brewery.

Families supplied with Genuine Home-Brewed Ale in Casks of any size.

Truman, Hanbury & Co.'s Stout.

ADVERTISEMENT.

Tower Brewery.

TRADE MARK.

H. CHAPMAN,

BREWER, MALTSTER,

AND

Spirit Merchant,

WORTHING.

LIST OF PRICES:

	4½	9	GALLONS. 18	36
F.P.A.	4/6	9/-	18/-	36/-
P.A. (Bitter)	5/6	11/-	22/-	44/-
I.P.A. (Bitter)	—	13/6	27/-	54/-
XX	4/6	9/-	18/-	36/-
XXX	6/9	13/6	27/-	54/-
BURTON	—	15/-	30/-	60/-
WORTHING NOURISHING STOUT	—	13/6	27/-	54/-
PORTER	4/6	9/-	18/-	36/-

H. CHAPMAN begs to direct particular attention to the above mentioned Ales, which are brewed from the Finest Malt and Hops that can be produced. The F.P.A. is a light bright Ale, especially adapted for family use, and its refreshing properties will thoroughly recommend it. The P.A. is an Intermediate Ale of superior quality. The I.P.A. is of the same character as the above, but stronger, and is, in fact, the perfection of Ale, being bright, sound and strengthening, with a pungent flavour peculiar to itself. The XX and XXX are nut-brown Ales, after the style of the old-fashioned English home-brewed.

Daily Deliveries throughout Worthing and Neighbourhood.

Worthing Nourishing Stout: Harry Chapman, Tower Brewery. (Deacon's Court Guide, 1881)

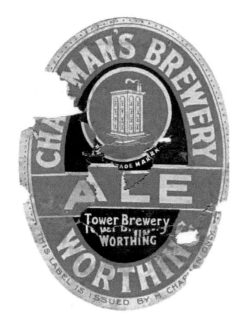
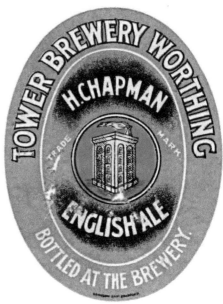

Above: Tower Brewery bottle labels. (Courtesy of the Eric Doré collection)

Left: The former Tower Brewery. (Author's Photograph)

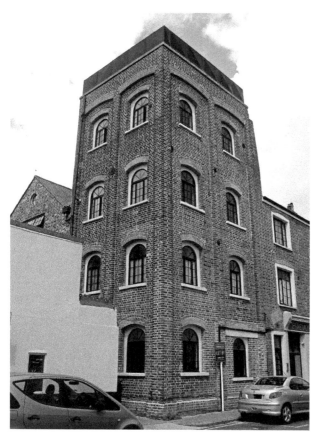

Rear of the former Montague Brewery, 1968. (Courtesy of West Sussex County Council Library Service, www. westsussexpast. org.uk)

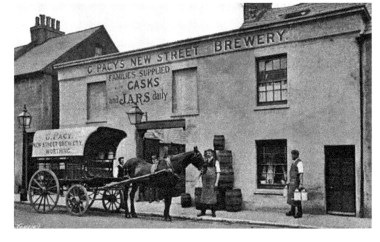

Pacy's New Street Brewery, 1895. (Courtesy of West Sussex County Council Library Service, www. westsussexpast. org.uk)

GEORGE PACY,

Wholesale Family Brewer

OF MILD AND BITTER ALES,

NEW STREET BREWERY, WORTHING.

Single and Double Stout. Good Nourishing Porter, 1/- per gallon.

Ales and Stout in Casks and Stone Jars with Taps.
Families supplied.

Good Nourishing Porter: George Pacy, New Street Brewery. (Brewery History Society Archive)

NOTED FOR OUR INVALID STOUT.

Our BITTER ALE at 1/6 is second to none in the County, and is supplied to many of the best families in Worthing and neighbourhood.

My Vans deliver in the Country and all parts of **Town Daily.**

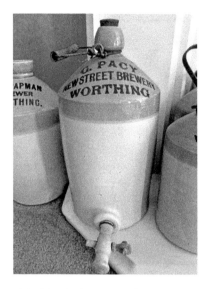

George Pacy, New Street Brewery stone jar.
(Courtesy of Chris Austin)

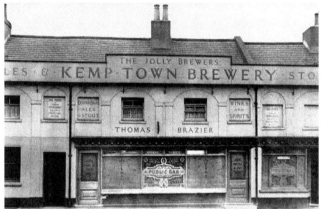

Jolly Brewers pub,
Worthing, 1920s. (Brewery
History Society Archive)

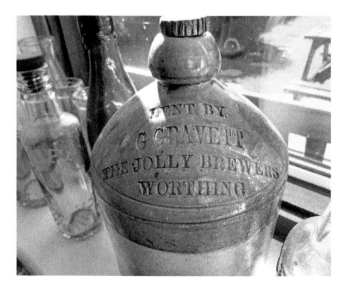

George Gravett, Jolly
Brewers stone jar.
(Courtesy of Chris Austin)

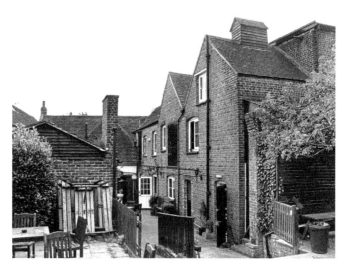

The former Vine Brewery buildings, West Tarring. (Author's Photograph)

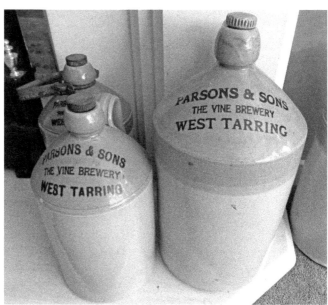

Parsons & Sons, Vine Brewery stone jars. (Courtesy of Chris Austin)

became a successful and respected businessman, but died without learning how to write his own name. Brewing continued until the early twentieth century, with the building eventually demolished in 1969.

Although Worthing residents were grateful for the pure water supply given freely from the well of the New Street Brewery during the town's typhoid epidemic of 1893, Mary Pacy, the eleven-year-old daughter of the brewery owner, died from drinking contaminated water from another source. Founded as a beerhouse in 1845 by William Clark, George Pacy, a keen rower, acquired the business in 1863. On his death in 1931, his son Sydney carried on brewing draught beer to supply their pub. The business was acquired in 1947 by the Stockwell Brewery of London, who demolished the brewery and built a new pub on the site.

George Gravett was operating from the Jolly Brewers in Clifton Road by 1898 until 1921 when brewing ceased after the pub was acquired by the Kemp Town Brewery of Brighton. The brewery was founded *c.* 1836 by William Palmer at what was originally the Brewers Arms. By 1858 it had passed to the Gravett family, who called it the New Town Brewery and eventually changed the name of the pub. The Jolly Brewers was rebuilt in 1929 and was demolished in 2015.

The extensive Vine Brewery buildings remain largely intact behind the Vine pub in West Tarring High Street. The pub was owned by the Parsons family from 1843 until the death of Henry Parsons in 1937, although brewing may have ceased prior to this. Pub and brewery were put up for sale in 1938 and acquired two years later by Friary, Holroyd & Healey of Guildford.

Lancing

Experienced brewer Rob Thomas established Naked Beer in 2013 with a five-barrel plant at the Modern Moulds Business Centre. Being 'Naked' in this context is to shed inhibitions and the shackles of convention – or, as Rob phrased it, 'to challenge the stigmas and perceptions of craft beer through the use of exotic flavours and abstract brewing techniques'. Naked entered the market with the two appropriately named beers, Streaker and Indecent Exposure. Brewing has been suspended at the time of writing.

Brewery on Sea was established by Jon Sale in 1990, but it was more than three years before he brewed by the sea. Beers such as Spinnaker Classic were initially contract-brewed at Premier of Stourbridge. Brewer Rob Jones (later of Dark Star) helped Jon set up at Winston Business Centre, producing their first local brew in May 1993. The brewery was sold in 1999 to Carl Thomas and John Allen, who renamed it Spinnaker Ales. The new owners, who came from a pharmaceutical background, closed the brewery in 2002 after problems guaranteeing future profitability.

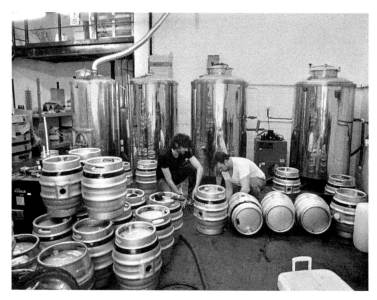

Naked Beer interior, Lancing. (Courtesy of Glenn Johnson)

Naked Beer
wooden pump clip.
(Author's Photograph)

Brewery on
Sea, Lancing.
(Courtesy of John Law)

Brewery on Sea, 1st
Brew bottle label.
(Courtesy of Dale
Adams)

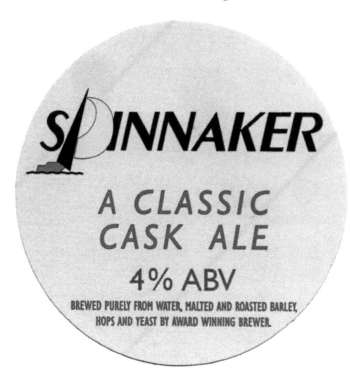

Brewery on Sea,
Spinnaker Ale beer
mat. (Courtesy
of Dale Adams)

Shoreham-by-Sea

The town's only major concern was the Albion Steam Brewery, a name it acquired
c. 1877, but the business may have been established as early as 1828, and it operated
under several different owners, with its offices based in Middle Street. Brewing ceased
after it was sold in 1889 to E. Robins of Hove. The brewery building dominated the
riverside at the eastern end of the High Street and was demolished in 1938 to enable
road widening.

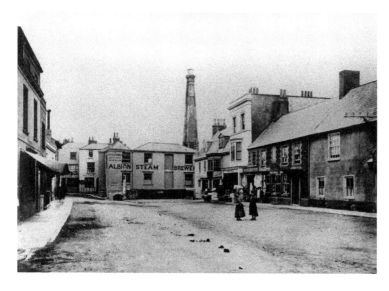

Albion Steam
Brewery,
Shoreham-by-Sea,
c. 1880. (Courtesy
of Marlipins
Museum, Sussex
Archaeological
Society)

Southwick

Jonny Booth and Laurie Vella started out in Essex in 2011 with their Pin-Up Beers contract-brewed by Harwich Town Brewery. They began brewing themselves a year later at Stone Cross, Crowborough, East Sussex, decamping with their five-barrel plant in April 2014 to the Chalex Industrial Estate. As for the brewery name, American Second World War bomber planes often had a glamorous 'pin-up' woman painted on the fuselage. Many yachts also display such figures, and Jonny and Laurie were once involved in the yachting trade – hence the names of two of their regular beers: Red Head and Honey Brown.

The original Southwick Brewery was formed *c.* 1790 by a four-man consortium headed by businessman Nathaniel Hall, who sold it in 1820 to Richard Tamplin. On 6 September that year, the thatched brewery burnt down. Uninsured but undeterred, Tamplin arose from the ashes to set up in Brighton as the Phoenix Brewery.

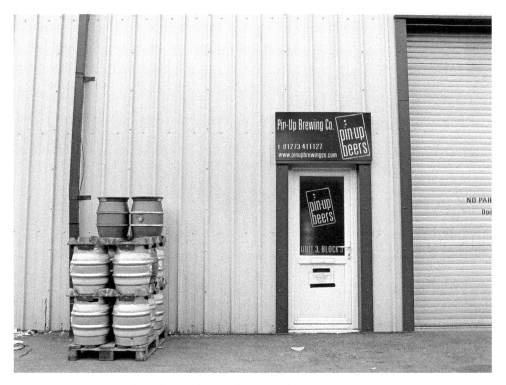

Pin-Up Brewery, Southwick. (Author's Photograph)

The South Downs and the Western Weald

The bold chalk escarpments of 'our blunt bow-headed, whale-backed downs' (Rudyard Kipling) form the backbone of Sussex. While sheep once cropped the springy turf, this pastoral vision has since given way to arable farming, but the image of the downs with its shepherds lingers in our national consciousness. Beyond their steep northern slopes lie Midhurst and Petworth, the two township capitals of the Western Weald, a hilly Greensand area of ancient heaths and woodland.

Poynings

Founded in 1851, the Poynings Brewery was in the hands of wealthy landowner George Stephen Cave Cuttress by 1855, trading as Cuttress & Son until 1925. It was acquired that year by a Major Molesworth, who recruited ex-Army comrades for his workforce. After brewing ceased in 1940, the brewery was used as an armaments factory for the remainder of the Second World War. It then became a metal workshop, before being demolished in the early 1960s.

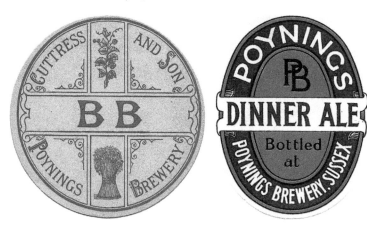

Cuttress & Son, Poynings Brewery bottle labels. (Courtesy of Pete Standen)

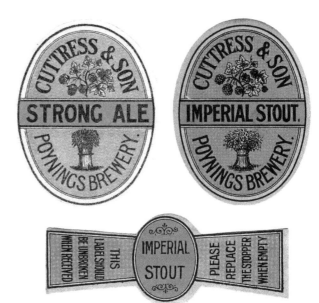

Cuttress & Son, Poynings Brewery bottle labels. (Courtesy of the Eric Doré collection)

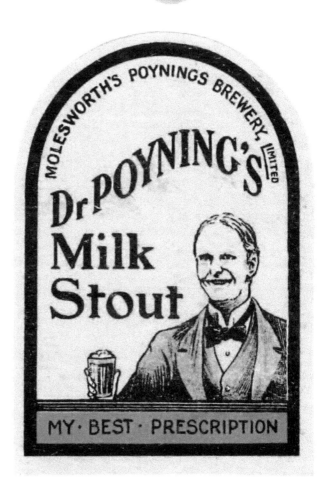

My Best Prescription: Molesworth, Poynings Brewery. (Courtesy of the Eric Doré collection)

Edburton

As a way of increasing profits for the Tillingbourne Bus Company, beer was once transported to public houses along the Brighton route from the Sussex Brewery at Truleigh Manor Farm, where Beverly Pyke and Mike Roberts brewed in the outbuildings on a five-barrel plant using malt extract. The brewery may have been founded as early as November 1979 but probably first brewed in either December of that year or January 1980. This makes it either the first or the second (after the Old Chidham Brewery) microbrewery in the county. Cranwell Investments purchased the brewery in December 1981 and moved it to Pulborough Industrial Estate, before entering into voluntary liquidation in August 1983.

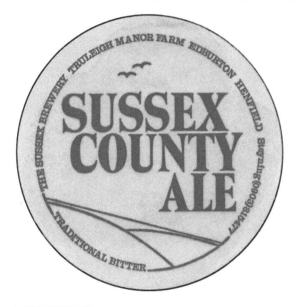

Sussex Brewery traditional bitter beer mat. (Courtesy of Dale Adams)

Sussex Brewery best bitter beer mat. (Courtesy of Dale Adams)

Sussex Brewery bottle label. (Courtesy of Dale Adams)

Small Dole

Downlands Brewery was originally called SouthDowns Brewery, a 2011 joint enterprise between brewer widdi, and Geoff, owner of the Shepherd & Dog pub in nearby Fulking village. The first beer, Ruskin's Ram, was named after writer John Ruskin, who applied the science of hydraulics to harness the power of the spring water and provide Fulking with a pumped supply. Brewing initially took place at Kent Brewery, with widdi supplying genuine samples of Fulking spring water for the mash. The first local brew on the ten-barrel plant at Mackley Industrial Estate was in August 2012, the change of brewery name following shortly afterwards.

Julian Spender was inspired to begin brewing by his experience of drinking Dark Star beers. He established the Baseline Brewery on the Golding Barn Industrial Estate in March 2012 using a custom-built five-barrel plant. The name of the brewery and its first beers – Thunderbolt, Dark Matter, and English Electric Lightning – were a nod to science and engineering. No isinglass (finings, obtained from fish bladders) were used to clear the beers, making them suitable for vegetarians. In 2014, Julian began bottling beers and opened a brewery shop, but closed the business the following year and sold the plant to Riverside Brewery.

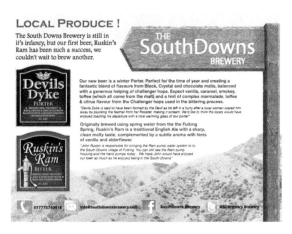

Beers with local connections: SouthDowns Brewery flyer. (Courtesy of widdi)

Hop Contract: Downlands
Brewery brochure.
(Courtesy of widdi)

Downlands Brewery van.
(Author's Photograph)

No Isinglass: Baseline
Brewery pump clip.
(Courtesy of Dave White)

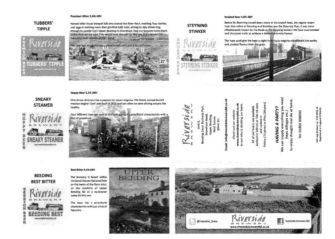

Beers with local
connections: Riverside
Brewery brochure.
(Courtesy of Mike Rice)

Upper Beeding

Keith Kempton, Mike Rice and Roger Paxton incorporated Riverside Brewery in
July 2015. Brewing takes place on the old Baseline plant, now installed at Beeding
Court Business Park. The beers all have names with local connections, such as Steyning
Stinker, recalling a steam train on the old branch line.

Steyning

Since late 2011, Adur Brewery has been owned and run by a co-operative, which
makes it unique in Sussex. It was originally formed as a limited company by Andy
Dwelly and Dicky Illing, and launched in May 2008 at a Church Ales event with beers
contract-brewed at Stumpy's of Hampshire. The first local brew on the 5.5-barrel plant
at Mouse Lane took place that July. The Adur Valley Co-operative continues to go
from strength to strength; the large part of its output is bottle-conditioned beer, which
sells well at local farmers' markets.

The brewing heritage of the town was laid down by two family firms. John Stoveld
had begun brewing in Dog Lane in 1772. Although his trustees continued to own the
brewery after his death, it was known as Michells Brewery after the family who had

Adur Brewery.
(Author's Photograph)

Gates Pale Ales poster.
(Courtesy of Steyning
Museum)

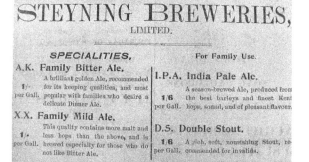

For Family Use: Steyning
Breweries advertisement, 1902.
(Courtesy of Steyning Museum)

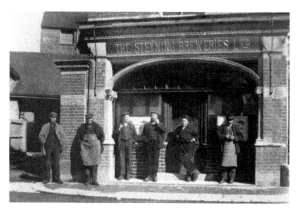

Workers outside the Steyning
Breweries offices, *c.* 1910.
(Courtesy of Steyning Museum)

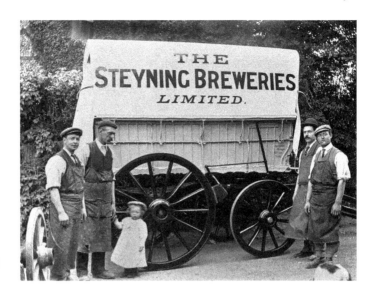

Steyning Breweries wagon, 1905. (Courtesy of Steyning Museum)

Steyning Breweries advertising poster by the London firm of Sir Joseph Canston & Son Ltd. (Brewery History Society Archive)

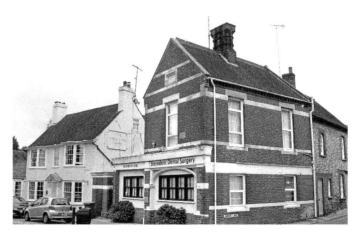

The former Three Tuns Inn and Steyning Breweries offices. (Author's Photograph)

run it since 1822 (and eventually bought it in 1879). George Gates, meanwhile, had established the Three Tuns Brewery in Jarvis Lane by 1828. The two firms merged in 1898, creating the Steyning Breweries at the latter site. Brewing ceased after a serious fire of 1917 and the buildings were sold at auction in 1920 to the Rock Brewery of Brighton.

Arundel

What was referred to in 1733 as the Old Brewery, located in Brewery Hill off Tarrant Street, was renamed the Arundel Brewery in 1829 and rebuilt in 1832 by the Puttock family in partnership with Robert Watkins, then steward to the Duke of Norfolk. Several other local brewers took strong objection to this development and petitioned the Duke to enforce their complaint, but to no avail. A final change of name to the Eagle Brewery probably occurred after the 1878 purchase by Lambert & Norris. Brewing ceased in 1910, when this partnership sold the brewery and its eighty-one pubs to Friary, Holroyd & Healey of Guildford. Edward Norris, sometime Mayor of Arundel, was killed the following August aged fifty-five, riding in the Hunter Class at the Arundel Horse Show.

The Swallow Brewery in Queen Street was in existence by 1783. The Constable family took sole control by 1832 through a marriage connection with the previous owners from 1803, the Puttocks. The Constables were a local family of carpenters who moved via property ownership into brewing, not only in Arundel but also at Littlehampton. Brewing ceased in 1921 following a merger with Henty & Sons of Chichester. Most of the brewery was demolished by 1930.

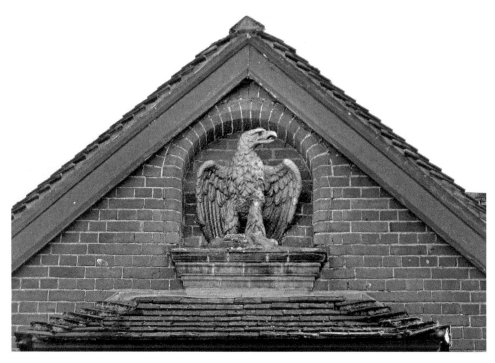

Eagle figure at the Eagle Inn, Arundel. (Author's Photograph)

The former Eagle Brewery offices. (Author's Photograph)

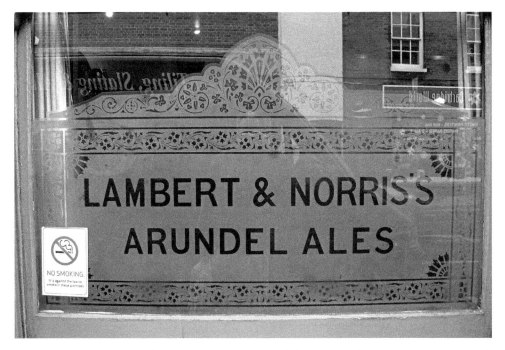

Lambert & Norris pub window at the Bush Inn, Chichester, since removed. (Author's Photograph)

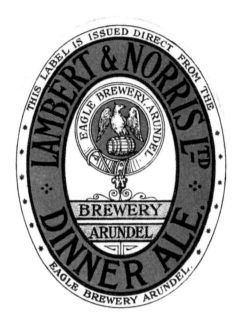

Dinner Ale: Lambert & Norris bottle label. (Courtesy of the Eric Doré collection)

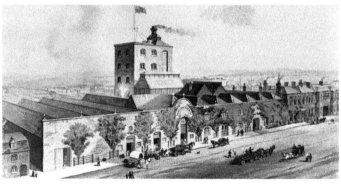

Swallow Brewery. (Courtesy of Arundel Museum)

Remnant of the Swallow Brewery, which is now antiques warehouses. (Author's Photograph)

The Old Brew House, Amberley. (Author's Photograph)

Amberley

The building in Church Street called the Old Brew House once provided the beer for the neighbouring Golden Cross beerhouse (now a private residence), one of the scores of small, retail publican breweries in the county during the nineteenth century.

Nyewood

Not only is Ballard's Brewery the oldest operating brewery in the county, it also retains its founding family ownership structure, while head brewer Fran Weston has been with the company for all but the first six months of its existence. Carola Brown (maiden

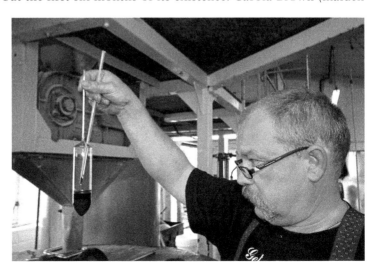

Ballard's brewer Fran Weston. (Courtesy of Scott Conway)

Ballards Beer Walk
Sunday 7th December 2008

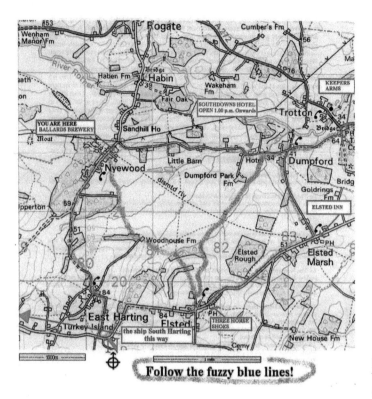

Ballard's Brewery Walk map. (Author's Collection)

name Ballard) began the brewery with husband Mike in July 1980 at Cumbers Farm, Trotton. After a move in 1985 to the Railway Inn, Elsted (renamed the Ballard's Inn), the brewery relocated in 1988 to the Old Sawmill, where a ten-barrel plant is used. The annual brewery charity walk was instituted that same year. This always takes place on the first Sunday in December, the occasion marked by the unveiling of the new bottle-conditioned beer in the Old Bounder series. With a typical strength of around 10 per cent, it fuels the walkers on their wanderings around this delightfully rural corner of the Western Weald.

Midhurst

The Angel Steam Brewery had been established at the rear of the Angel Hotel in the early 1800s but it was remodelled with extensive use of copper in 1887 by then owner and hotel landlord John Parker. The brewery continued to trade under Parker's name after his death in 1896, becoming Parker & Popplewell (after managing partner Thomas Popplewell) in 1917. Brewing ceased in 1923 when the hotel and brewery were purchased by Gales of Horndean.

ANGEL HOTEL,
MIDHURST.

JOHN PARKER,
PROPRIETOR.

*This Excellent Hotel, patronised by the
Nobility and Gentry, is situated in one of the best
parts of the Town, and adjacent to Cowdray Park
and Ruins. It is replete with every comfort, and
the cuisine arrangements are not to be surpassed.*

Wines and Spirits of Every Description.

Angel Steam Brewery,
MIDHURST.

Families supplied with Ales and Stout in
4½, 9, 18 and 36 Gallon Casks.

BASS'S PALE ALE IN BOTTLE.

SCHWEPPE'S AND OTHER MINERAL WATERS.

John Parker, Angel Steam Brewery.
(Deacon's Court Guide, 1881)

Angel Hotel, Midhurst.
(Author's Photograph)

Lodsworth

A swallow used to nest in the stable-yard eaves at the converted eighteenth-century granary barn that is home to Langham Brewery. The bird inspired the brewery logo and gave the name to Black Swallow, a 6.0 per cent Black IPA gold medal winner in the 2015 SIBA South East Regional Competition. The steam-powered brewery commenced in May 2006 and is currently owned by James Berrow and Lesley Foulkes. All components of the ten-barrel plant have alliterative names: Cathy the copper, Martha the mash tun, Fiona, Fatima, Freda and Fanny the fermenters. October sees the annual Brewery Conker Championship – inaugurated in 2008 – advertised by the strapline, 'Are you bonkers for conkers?'

Converted eighteenth-century granary barn: Langham Brewery. (Author's Photograph)

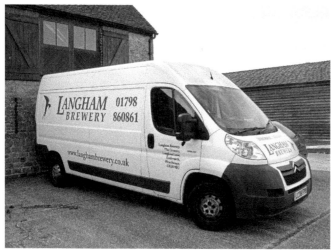

Langham Brewery van. (Author's Photograph)

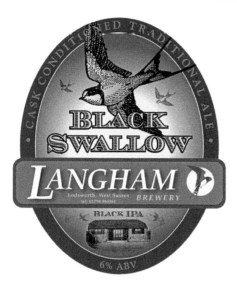

Award-winning beer: Langham Black Swallow pump clip. (Courtesy of Lesley Foulkes)

Petworth

The maltster and brewer team of Wild & Greenfield were operating at the ancient Angel Inn, Angel Street, from *c.* 1828–39.

James Milton established the Stag Brewery behind the White Hart in the High Street *c.* 1845. It passed through the family in 1872 to Milton Manning who, in 1899, decided to cease brewing and sell up. The brewery and its estate of three pubs were purchased the following year by Friary, Holroyd & Healey of Guildford, who did not resume production at Petworth.

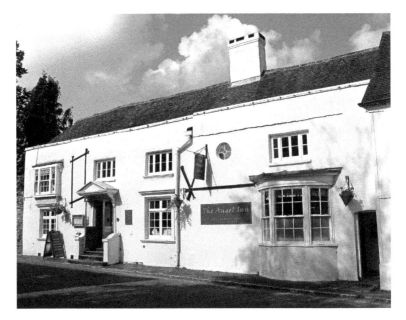

Angel Inn, Petworth. (Author's Photograph)

The former Stag Brewery. (Author's Photograph)

The Low Wealden Clay Plain and the Mid-Sussex Towns

The name Weald is derived from the Old English word for forest. The entire Sussex Weald was indeed once densely forested until much timber was felled for use in medieval shipbuilding and as fuel for charcoal burners. The flat and watery landscape of the Low Weald affords long views across miles of countryside to the mid-Sussex commuter towns of Burgess Hill and Haywards Heath, both vastly expanded by the 1841 arrival of the railway. The clay base of the land gave rise to a pottery, tiles and brickmaking industry that flourished until the early twentieth century.

Parham

Keith Donoghue began Baldy Brewery at Southwater on a 100-litre kit in summer of 2012, crafting a range of cask ales for all seasons and tastes with new recipes and specials being added regularly. His Kiln Dust porter paid homage to Southwater's brickmaking heritage. Shortly afterwards, Keith moved operations to the Old Sawyard on Parham House Estate before ceasing brewing in 2014 to pursue a career in engineering.

West Chiltington

After being inspired by the high-octane, hop-forward brewpub culture of North America during a 2012 visit, artists Nick and Sarah Allen began home brewing on a 200-litre whole-grain kit. A third-hand five-barrel plant eventually displaced their two cars in the double-garage of Watershed, their adapted former Southern Water workshops in Smock Alley. Formed in 2014, Greyhound Brewery was so named because the brew kit was delivered at the same time as a classic two-door coupé AC Greyhound car; meanwhile a friend was also paying a visit, accompanied by Fabio, her greyhound dog.

Partridge Green

What is now the biggest brewery in the county began in autumn 1994 with a one-barrel enthusiast's kit in the cellar of the Evening Star pub in Brighton, then co-owned by Peter Skinner. Dark Star Brewery was named after the beer that Rob Jones (who set

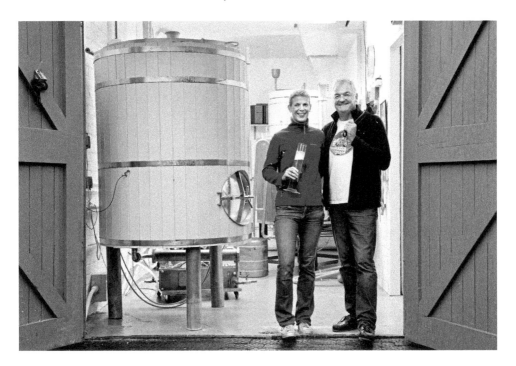

Above: Sarah and Nick at the Greyhound Brewery. (Courtesy of Nick and Sarah Allen)

Right: Greyhound Brewery logo. (Courtesy of Nick and Sarah Allen)

up that cellar kit) created at Pitfield Brewery of London, and which went on to be crowned 1987 CAMRA Champion Beer of Britain. Rob had named the beer after a song by the band The Grateful Dead. Rob was soon joined in brewing at the Evening Star by ardent home-brewer, art student and punk rock fan, Mark Tranter. The brewery relocated in July 2001 to Moonhill Farm, Ansty, with Rob and Mark using a new fifteen-barrel plant. Here they produced the golden-hued, highly hopped beers for which the brewery became renowned, but did so alongside darker brews, both classic and experimental. A new forty-five-barrel brewery was formally opened in January 2010 on the auspiciously named Star Road Estate, Partridge Green. Mark Tranter left in 2013 to form his own brewery, Burning Sky of Firle, East Sussex. Rob Jones is currently at one of the brewery's pubs, the Duke of Wellington in Shoreham-by-Sea, where he has plans to open a brewhouse.

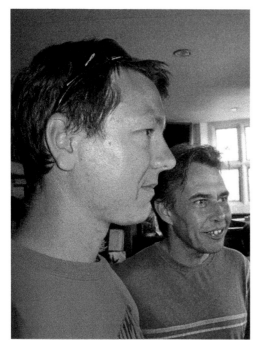

Left: Star turn: former Dark Star brewers Mark Tranter and Rob Jones. (Author's Photograph)

Below: Dark Star plant at Ansty. (Author's Photograph)

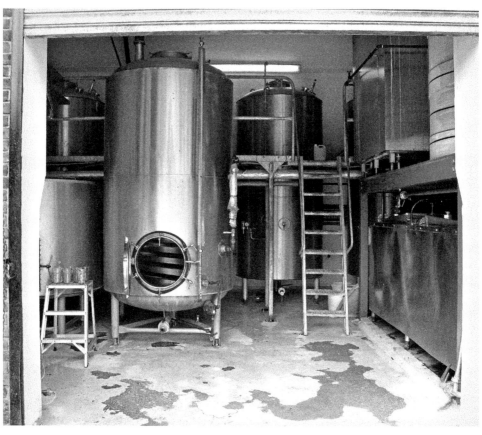

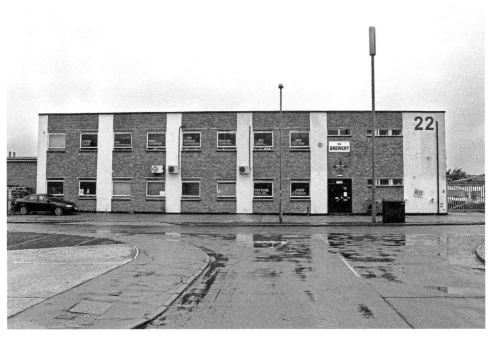

Wet day at Star Road: Dark Star Brewery at Partridge Green. (Author's Photograph)

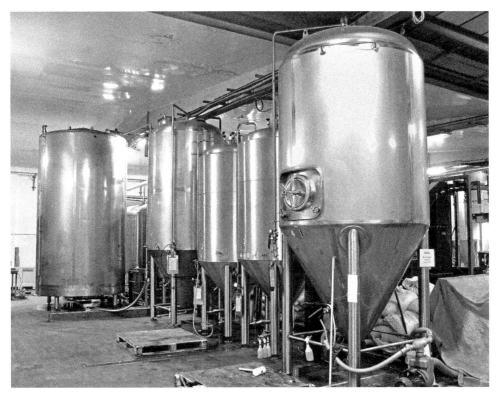

Dark Star plant at Partridge Green. (Author's Photograph)

Old Malthouse of the
Mockbridge Brewery.
(Courtesy of Alan Barwick,
Henfield Museum)

Mockbridge
The Bowler family were operating the Mockbridge Brewery at Bottings Farm, north
of Henfield, by 1869. Brewing ceased after Frank Bowler's son was killed in the First
World War.

Albourne
Bedlam Brewery commenced brewing in May 2012 at Albourne Farm, behind which
runs Bedlam Street, the old Roman road from Albourne to Hurstpierpoint. Dominic
Worrell, owner of the Bull Inn, Ditchling, took over as director of the brewery in
July 2014 with the aim of expanding the operation on the existing premises. The
company is proud of its green credentials: the hops are grown on-site and electricity is
generated by solar panels on the brewery roof.

Modern Brews, Centuries of Tradition:
Bedlam Brewery advertisement.
(Courtesy of Bedlam Brewery)

Hurstpierpoint

In 2012, a group of locals at the White Horse Inn, led by landlord Simon Hallworth, revived a name and a tradition of brewing in the village that had ceased a century earlier. Located in an outhouse behind the inn, the four-barrel Hurst Brewery was launched with 700 Summer Ale, to mark the 700th anniversary of the granting of a charter for the village's St Lawrence fair. The original Hurst Brewery in Cuckfield Road was founded by 1862. It was first run by the Smith family, landlords of the New Inn, where brewing may previously have taken place, then by George Thomas Saltmarsh and finally by antiquary John Edwin Couchman, until he sold out in 1912 to the West Street Brewery of Brighton.

Continuing the Tradition: Hurst Brewery poster. (Author's Photograph)

Hurst Brewery behind the White Horse Inn. (Author's Photograph)

The former
Hurst Brewery.
(Author's
Photograph)

Burgess Hill

The Kiln Brewery in Alexandra Road was incorporated in March 2014 by Craig Wilson and Andrew Swaisland. They describe their nano operation as 'dedicated to creating the types of beers we like to drink: unfiltered, unpasteurised and most importantly full of great flavour.' The old kiln-fired brick and tilemaking industry of the town is reflected in the name of the brewery and its Bricks and Porter beer.

The Railway Tavern in Station Road was a Whitbread pub in June 1983 when it began malt-extract brewing. The Burgess Brewery produced Best, Railway Special and Winter Brew before ceasing in 1985/6.

The St John's Brewery was founded by 1861 behind the Brewers Arms in London Road by Thomas Charman. His successor of the following decade, Thomas Stroud, commended Charman publicly for providing him with 'liberal support' for his venture. Stroud had leased the brewery by the mid-1880s to Charles Pitcher who, from the

Kiln Brewery
logo. (Courtesy of
Craig Wilson)

Beer with a local connection: Bricks and Porter pump clip. (Courtesy of Craig Wilson)

Railway Tavern brewpub, Burgess Hill, 1984. (Courtesy of John Law)

Burgess Brewery beer mat. (Courtesy of Ian Mackey)

T. S. STROUD,
"St. JOHN'S BREWERY," BURGESS HILL.

T. S. STROUD begs to convey his most sincere thanks for the very liberal support accorded him since he succeeded Mr. Charman, and trusts to receive a continuance of the same. The trade having far exceeded his expectations, he has found it necessary to add Steam Power, which is now completed, and enables him to keep a larger Stock, thus giving age before Goods are sent out.

He has now completed his October Brewings, which he can strongly recommend for their keeping qualities.

PRICE LIST.

	FIR.	KIL.			FIR.	KIL.
Fine Keeping Bitter Ale ...	7/6	15/-	Good Mild Ale, X		6/-	12/-
Ditto , ditto strongly			Ditto XX		9/-	18/-
recommended	9/-	18/-	Porter		9/-	18/-
Ditto ditto	10/6	21/-	Stout—superior—equal to			
Ditto ditto	13/6	27/-	London		13/6	27/.

Bass & Guinness's Bottled Ale & Stout at List Prices.

☞ ORDERS RECEIVED BY MR. JAMES WOOD, CUCKFIELD.

Keeping Ale: Thomas Stroud, St John's Brewery. (Clarke's Directory, 1879)

CHAS. H. PITCHER, BREWER,
Malt, Hop, Coal, Coke, and Wood Merchant,
ST. JOHN'S BREWERY,
London Road, Burgess Hill.

PRICE LIST.

T	ALE ..	℔ Gal. 0s. 6d.	PORTER	℔ Gal. 1s. 0d.			
T	,, No. 1	,, 0s. 8d.	SINGLE STOUT	,, 1s. 3d.			
X	,, ..	,, 0s.10d.	DOUBLE ,,	,, 1s. 6d.			
XX	,, ..	,, 1s. 0d.	BITTER BEER	,, 1s. 0d.			
XXM	,, ..	,, 1s. 3d.	,, ALE	,, 1s. 3d.			
XXX	,, ..	,, 1s. 6d.					

The above Ales are guaranteed to be brewed from Pure Malt and Hops of English growth.

Bass's and Guinness's Bottled Ale and Stout at List Prices.

Supplied by the Truck or Ton, or in smaller } **COALS** { quantities, at the Lowest Market Prices.

AGENT: MR. JAMES WOOD, CUCKFIELD.

Charles Pitcher, St John's Brewery. (Clarke's Directory, 1887)

A. B. HYDE,
Porter, Stout, Pale & Bitter Ale Brewer,
"BRIDGE BREWERY," St. John's Common, Burgess Hill.

—·+·+·—

TERMS CASH.

A. B. Hyde, Bridge Brewery. (Clarke's Directory, 1879)

evidence of advertisements, expanded the beer range. Stroud returned in the 1890s, eventually to cease brewing.

The Bridge Brewery, Fairplace Hill, St John's Common, was operating by 1877 under Alfred Benjamin Hyde. Nothing more is known after it was sold by the Hyde Brothers in 1882.

T. W. BEST,
BREWER AND MALSTER,
AND WINE AND SPIRIT MERCHANT,
CUCKFIELD.

AGENT FOR SIR HENRY MEUX & CO'S LONDON STOUT.

Thomas Best, Cuckfield. (Melville & Co.'s Directory, 1858)

J. LANGTON,
(Late T. W. BEST)
"THE BREWERY,"
CUCKFIELD.

PRICE LIST.

	4½ Galls.	9 Galls.	18 Galls.	36 Galls.
X ALE ...	3/9	7/6	15/-	30/-
XX ,, ...	4/6	9/-	18/-	36/-
XXX ,, ...	6/9	13/6	27/-	54/-
PORTER ...	4/6	9/-	18/-	36/-
SINGLE STOUT ...	6/9	13/6	27/-	52/-
DOUBLE ,, ...	7/6	15/-	30/-	60/-
BITTER BEER	9/-	18/-	36/-
PALE ALE	10/6	21/-	42/-
INDIA PALE ALE	13/6	27/-	54/-

TERMS CASH.

Joseph Langton, Cuckfield. (Clarke's Directory, 1879)

Part of the former Dolphin Brewery, Cuckfield. (Author's Photograph)

Cuckfield

What was known simply as The Brewery was founded in the High Street *c.* 1855 by Thomas William Best. It was acquired in 1877 by Joseph Langton, who, a decade later, renamed it the Dolphin Brewery. It was purchased with its eight pubs in 1898 by the Southdowns & East Grinstead Breweries, who subsequently sold the plant and used the site as a depot.

Haywards Heath

Heathen Brewery was launched on 21 September 2014 at the local Broadway Village Fete and Ale Festival. The 2.5-barrel plant in the basement of the Grape & Grain delicatessen and off-licence is probably the only brewery in an offie in the UK. The brewery name captures the business ethos of the five brewer-owners, which is 'edgy, to break the mould and do things differently from the brewing establishment.' This aspect of experimentation can be seen not only in eclectic range of styles produced – Belgian farmhouse, porter, bitter, old ale, dark IPA – but in the use of ingredients such as honey, rhubarb, mulberry, meadowsweet, black treacle, coco and figs.

Home brewer Al Madock began commercial brewing as Top Notch in late 2013 on a 0.5-barrel kit in his converted residential outbuilding, upgrading to one-barrel in 2016. He has recently collaborated with Heathen Brewery to produce Old Chuffer, a vintage smoked porter, to commemorate 175 years of the local railway line.

Peter Skinner, ex-Dark Star, brewed again as Custom Beers in an outbuilding at Little Burchetts Farm from February 2005 to June 2008, using a custom-built five-barrel plant. A regular range of beers was complemented by a 'custom service', with Peter

Heathen Brewery banner. (Courtesy of Ed Perfect)

Top Notch Brewery logo. (Courtesy of Al Maddock)

Oxymoronic hybrid style, Dark IPA. (Courtesy of Al Maddock)

Custom range. (Author's Collection)

Power & Co., Haywards Heath. (Clarke's Directory, 1879)

H. S. VERRALL,
THE BREWERY, HAYWARDS HEATH.

PRICE LIST.

	36 Gal.	18 Gal.	9 Gal.			36 Gal.	18 Gal.	9 Gal.
XXXX	- 54/-	27/-	13/6	BA (Light Bitter Ale)	36/-		18/-	9/-
XXX	- 42/-	21/-	10/6	BAK (Bitter Ale)	54/-		27/-	13/6
XX	- 36/-	18/-	9/-	PORTER -	- 36/-		18/-	9/-
X	- 30/-	15/-	7/6	D. STOUT -	- 52/-		26/-	13/-

Also in 4½ Gallon Casks.

Bass's Ale and Guinness's Stout in Bottles.

TERMS :—

For Cash on Delivery an allowance of 2s. on 36 Gallons; 1s. on 18 Gallons; 6d. on 9 Gallons; or an Approved Monthly Account, subject to Half this Allowance.

CARRIAGE PAID TO ALL STATIONS.

Above: Harry Verrall, Haywards Heath. (Clarke's Directory, 1883)

Right: Alfred Crawshaw, Haywards Heath. (Clarke's Directory, 1884)

44 HAYWARDS HEATH.

A. T. CRAWSHAW,
The Brewery, Haywards Heath.

→ LIST ·÷· OF ·÷· PRICES. ←

Ale and Stout.		Mineral Waters.	
	Per Gall.		Per Doz.
XXXX Ale	2/-	Seltzer	2/-
XXX ,,	1/6	,, Split	
XX ,,	1/-	Soda	1/6
X ,,	8d., 10d.	,, Split	1/-
Best Stout	1/6	Lemonade	1/6
Porter	1/-	,, Split	1/-
	Doz. Impl. Pta. / Doz. Rptd. Pta.	Ginger Beer	1/6
Bass's Bottled Ale,	5/-, 4/6, 3/6	Ginger Ale	1/6
Guinness's Bot. Stout,	5/-, 4/6, 3/6		

THE BEST
WALLSEND AND KITCHEN
COALS

Supplied by the Truck or Ton, or in Smaller Quantities, At the Lowest Market Prices.

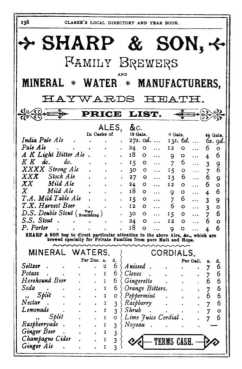

Sharp & Son, Haywards Heath.
(Clarke's Directory, 1887)

happy to consider brewing beers on request from customers, who were encouraged to suggest new options for styles, flavours, names and designs. 'Think it! Drink it!' was his advertising slogan.

The Haywards Heath Brewery in Mill Green Road was the town's only Victorian brewing venture. Formed by Power & Blest in 1874, it was subsequently solely owned by Power in 1877, and then by Harry Verrall in 1881, Alfred Cranshaw in 1883 and Sharp & Son in 1887. The advertisements placed by this succession of owners are valuable in detailing the changing range of beers produced and prices charged. The enterprise ended disastrously in 1889 when the brewery caught fire. Mr Sharp Jr was in London, and so it was the next in command, Mr Maynard, who was roused from his bed to find the building almost completely destroyed.

Lindfield

The Lindfield Brewery was established by 1814 by Richard Buckley Stone. The local Durrant family had become sole owners by 1828. Grocer and draper Edward Durrant subsequently built the Stand Up Inn as a beerhouse adjacent to the brewery and his shop. The inn name arose from its lack of tables and chairs, for Edward wanted his workforce to return promptly to their duties and not sit lingering over their beer. 'Let them stand up and drink up!' he was reputed to have said. Upon his death in 1902, his widow, Fanny Sara, continued the business with son Bartley for four years. The brewery and its four pubs were sold in 1909 to Ballard's of Lewes. The brewery's open-sided horse gin (horse-powered watermill) has been restored and re-erected in the garden of the Red Lion pub in the village.

EDWARD DURRANT,

BREWER

HIGH STREET, LINDFIELD.

Family Bitter Ale One Shilling per Gallon.

AGENT FOR H. R. WILLIAMS & CO'S. GENUINE WINES AND SPIRITS.

EDWARD DURRANT,

FAMILY GROCER & DRAPER.

Embroideries, Wools, Silks, Braids, Jewelry, & General Fancy Goods.

MODERN & ANTIQUE CHINA, POTTERY, &c.

Above: Grocer, draper and brewer Edward Durrant, Lindfield. (Clarke's Directory, 1879)

Right: Fanny Sara Durrant, photograph at the Stand Up Inn. (Author's Photograph)

Fanny Sara Durrant, signage at the Stand Up Inn. (Author's Photograph)

Durrant Brewery horse gin. (Author's Photograph)

The Forest Ridge

The High Wealden Forest Ridge is a densely coppiced region that extends each side of the old settlements of Horsham and East Grinstead, while encompassing the new town of Crawley. The complex sandstone and clay-based landscape of cliffs, crags and valleys was once an important centre of the iron-working industry, its blast furnaces worked by waterpower from hammer ponds.

Ashurstwood

The Ashurstwood Brewery was set up in December 1983 in an outside toilet at the Three Crowns pub. It was the only brewpub of the Phoenix Brewery, a Brighton-based non-brewing arm of Watneys. Landlord Colin Stevens used a malt extract to produce Session Bitter and Strong. Brewing ceased *c.* 1986.

Ashurstwood Brewery bottle label. (Courtesy of Dale Adams)

East Grinstead

Experienced home brewer Andy Somerville established his artisan High Weald Brewery at Bulrushes Farm Business Park in early 2013, growing capacity to four-barrels. The local landscape and its iron-working heritage are reflected in beers such as Greenstede Golden Ale and Charcoal Burner Oatmeal Stout. Andy achieves a blending of the traditional and modern, brewing classic Sussex beers with locally sourced, subtle, spicy hops alongside feisty pale ales with punchy, New World hops.

The Grinstead Brewery was formed in July 1980 by George Spooner in the outbuildings of the Dunnings Mill pub where, until 1982, Eric Haskell brewed three barrels a week of Grinstead Bitter. The business recommenced from March until October 1985 under new owner Brian Watson, with locals Gordon McDonald and Howard Brown brewing in their spare time. The label of their bottled Bluebell Railway Silver Pale Ale shows a slight change in the brewery name to Grinstede, which is similar to the aforementioned 'Greenstede' – this is Old English for a green space or, more specifically, a green, inhabited clearing in a forest.

The last of the town's large brewers was the Southdown & East Grinstead Breweries, formed in 1895 by a merger of A. G. S & T. S. Manning's Southdown Brewery of Lewes with Dashwood & Co. The latter firm's Hope Brewery in London Road was so named after a possible rebuilding during the partnership of Burt & Hooker, *c*. 1838–44. John Dashwood took over in 1877, building up a twenty-pub estate. The brewery was demolished after Southdown & East Grinstead was acquired by Tamplins of Brighton in 1924, but the malthouse still stands.

High Weald brewer Andy Somerville. (Courtesy of Mark Newton Photography, www.marknewtonphotography.co.uk)

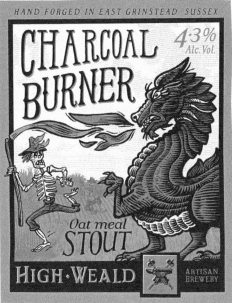

Above: Hand-forged artisan beers with local connections. (Courtesy of Andy Somerville)

Right: Grinstede Brewery bottle label. (Courtesy of Dale Adams)

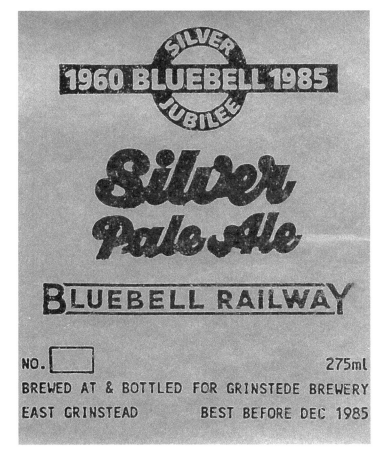

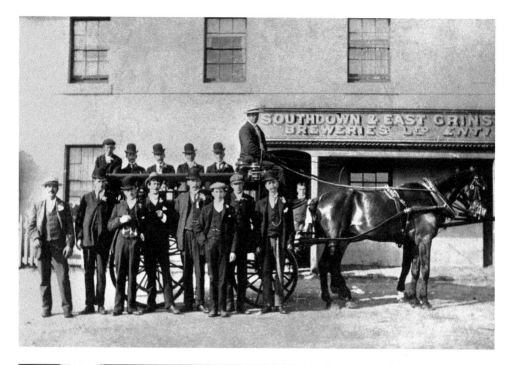

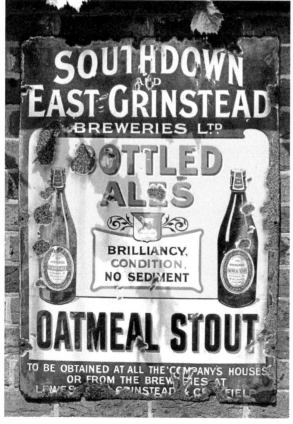

Above: Harold Hewitt Nutt vehicle and horses outside the Southdown & East Grinstead Breweries, *c.* 1910. (Courtesy of East Grinstead Museum)

Left: Oatmeal Stout: Southdown & East Grinstead Breweries tin advertisement. (Author's Photograph)

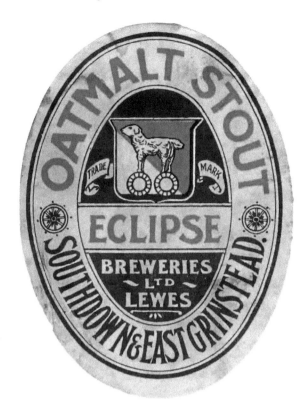

Right: Oatmalt Stout:
Southdown and East Grinstead
Breweries bottle label. (Courtesy
of the Eric Doré collection)

Below: Crooked Brook logo.
(Courtesy of Juha Nakari)

Copthorne

Simon Howard established Crooked Brook as a traditional cask ale producer in 2014 but sold to Simon Dismore and Juha Nakari in November 2015. Their best bitter, Prizefighter, recalls the pugilists that once boxed bare-knuckled on nearby Crawley Down. The brewery is named after the brook that does indeed run crookedly past the site and southwards on through the woods.

Crawley

The location of the Crawley Brewery of 1866 is uncertain, but the proprietor was probably Alfred Swonnell (1828–86), a commercial traveller and hop merchant of London who was made bankrupt in the 1860s. Locally born Henry Holder was brewing *c.* 1869–73, possibly just south of the old railway station at the junction of Oak Road and West Street. Holder left Crawley to become a publican but returned in 1890–92 as a brewer before departing again by 1901. Draper and furniture dealer George Chantler was brewing in the High Street *c.* 1870–78. His brewery and shop inhabited the fifteenth-century timber-framed house that was later converted to the Brewery Shades pub.

Charles Ockenden, a carpenter by trade, was at the George Hotel in the High Street by 1855 and may have been brewing there from 1866–70. From 1874–81 he was occupying the Station Brewery. This was subsequently run by his brother George, a tailor and hatter,

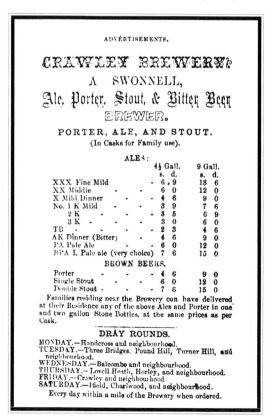

Alfred Swonnell, Crawley Brewery. (The Narratives of Miss Selina Worrits, 1866)

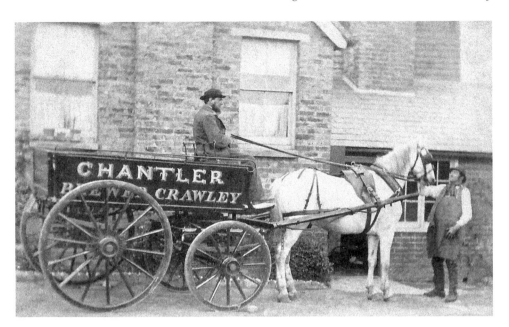

Above: Draper, furniture dealer and brewer George Chantler. (Courtesy of Graham Chantler)

Right: Charles Ockenden, George Hotel. (The Narratives of Miss Selina Worrits, 1866)

G. Ockenden & Son

(C. J. OCKENDEN),

❊ Brewers, ❊

Wine and Spirit Merchants,

New Road Brewery,

. . . CRAWLEY.

AGENTS FOR THE
Bodega Company's
Wines and Spirits,

In Cask and Bottle.

Left: George Ockenden & Son, New Road Brewery. (Pike's Blue Book, 1900)

Below: The Famous Old Brewery. (Author's Photograph)

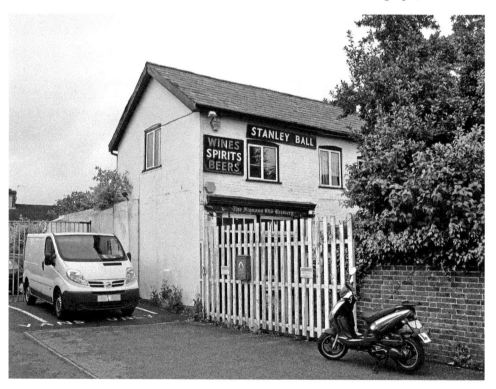

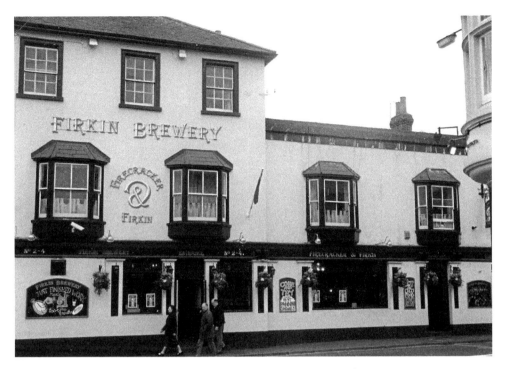

Firecracker & Firkin brewpub. (Brewery History Society Archive)

and by 1874 their second town site had been opened, the New Road Brewery. The C. J. Ockenden in brackets on the advert was George's son, Charles J. The breweries closed after being acquired in 1907 by Southdowns & East Grinstead Breweries. The Station Road site was purchased in 1921 by wine merchant Stanley Ball. The building today bears the sign 'The Famous Old Brewery.' New Road no longer exists.

Before taking the George Hotel, the aforementioned Charles Ockenden was the proprietor of the Station Inn, renamed The Railway in 1885. As the Firecracker & Firkin, it was equipped with its own brewkit from 1997–99 as part of the Firkin Brewery chain.

Lower Beeding

Kissingate was Crawley's first family-run brewery for over a century. Husband and wife team Gary and Bunny Lucas began commercial production on a 1.5-barrel plant in their converted garage in April 2010, relocating the brewery to Lower Beeding later that year. A further expansive move took place in 2012 to a new barn conversion on the same Church Lane Farm Estate. Like the 'cottage brewers' of the late Middle Ages, Gary often flavours his handcrafted beers by the addition of herbs, fruits and spices. But, while inspired by the past, Gary and Bunny also think deeply about the future and never miss an opportunity to create something new, such as the hybrid style Mandarina Red IPA. A 'kissing gate' is one that swings in a U-shaped enclosure and touches (kisses) each of two gateposts. The brewery was named after such a gate, which once stood at a local beauty spot where couples embraced.

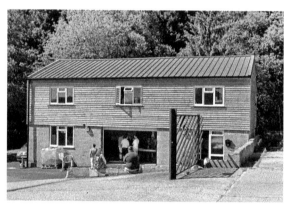

Above left: Kissingate brewer Gary Lucas. (Author's Photograph)

Above right: The tastes of yesteryear to enjoy today. (Courtesy of Gary Lucas)

Left: Kissingate Brewery, Pole Barn. (Author's Photograph)

Below left: Kissingate cask formation. (Author's Photograph)

Hybrid style, Kissingate
Mandarina Red IPA.
(Courtesy of Gary Lucas)

Horsham

The closure in 2000 of the Horsham Brewery of King & Barnes was the end of the line for the county's old family brewers. An increase in capacity had occurred as recently as 1980, when a new brewhouse was opened alongside the old one in the Bishopric. Yet major organisational changes of 1999 saw twenty staff made redundant, including head brewer Andy Hepworth. The shareholders rejected a takeover bid of that year from Shepherd Neame of Kent, but accepted an offer in April 2000 from Hall & Woodhouse of Dorset. The fate of the firm was thus sealed by much the same process of merger, acquisition and closure by which it had originally expanded.

James King arrived in Horsham in 1850 to trade as a maltster in the Bishopric. The close trading relationships he formed with the town's family brewers led to his amalgamation in 1862 with the Satchells of the North Parade Brewery. Their brewery was closed in 1870 and brewing transferred to the Bishopric. King eventually gained sole control, trading as King & Son. After his death in 1877, his sons, Charles, Fredrick and John, continued the business. The East Street Brewery had meanwhile been founded *c.* 1800 and passed in 1878 into the hands of the Barnes family, trading as G. H. Barnes (after George Hodsoll Barnes). The business was merged in 1906 with King & Sons, thereafter trading as King & Barnes, and the East Street Brewery was closed.

Other old breweries in the town included the North Street Brewery and the Fountain Brewery, both founded in the late 1700s, possibly by Richard Thornton, who was declared bankrupt in 1820. James Thornton ran the North Street Brewery from *c.* 1858–73, after which it is finally listed (until 1877) under a Mrs Elizabeth Caroline Thornton, probably his widow.

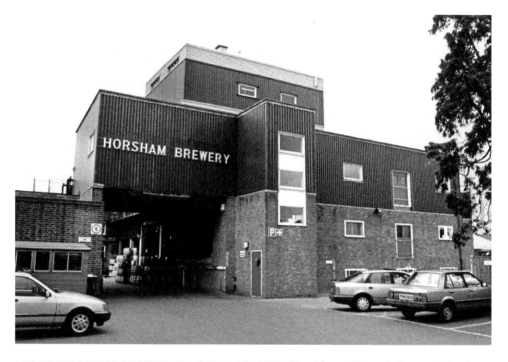

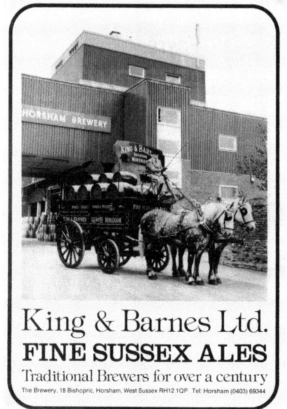

Above: King & Barnes Horsham Brewery. (Brewery History Society Archive)

Left: Modern brewhouse, traditional dray. (Author's Collection)

King & Barnes motorised dray. (Brewery History Society Archive)

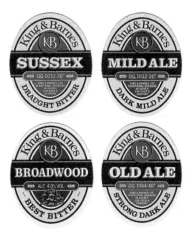

King & Barnes beer mats. (Author's Collection)

FROM

Established 1800

KING & SONS Ltd.

BREWERS, MALTSTERS

The North Brewery
BISHOPRIC.

AND

Mineral Water Manufacturers.
Wine and Spirit Merchants,
Beer and Cider Bottlers, &C.

The Wine Vaults,
15, CARFAX.

Chief Offices, 15 Carfax. / *Branch Office, The Bishopric.*

HORSHAM

Ales, Stout & Porter in 4½, 6, 9 & 18 gall. Casks.

	per gall.			per gall.
XXXX STRONG AMBER ALE	2 -	BA BITTER ALE	1/4
XXX MILD ALE	1 4 & 1 6	BB „ BEER	1/-
XX „	10d. & 1 -	B „ „ (Light)	...	10d.
X TABLE	6d. & 8d.	LS EXTRA STOUT	...	1 4 & 1 6
		S STOUT	1/3
		P PORTER	1/-

"H" **Household Beer, brewed exclusively
from finest Malt & Hops 9d. per gall.**

Fremlin's Maidstone Ales in 4½, 9 & 18 gallon Casks.

SPIRITS.		per bottle.	WINES.			per bottle.
GIN	2/-	2 6	PORT	... 1 4 1/6 1/9	2/-	2/6 &c.
WHISKY (Scotch)	2 6 3/-	3 6	SHERRY	...	1/6	2/6 &c.
Do. (Irish)	2 6 3 -	3/6	CLARET	... 1/-	1/6	2/- &c.
BRANDY ...	2 6 3 -	3 6 &c.	CHAMPAGNE	...	2/6	3/- 5/3 &c.
RUM ...	2 6 3 -	3 6	BURGUNDY	...	1/9	2/- &c.

ALES AND STOUT.	1 Gallon Flagons with Screw Stoppers	Impl. Pint Bot	Imperial ½-Pints Per doz Bot
BASS & Co.'s I.P.A. ...	1/- 4 6	4½d.	2/6 2½d.
GUINNESS'S EXTRA STOUT ...	1/1 4/-	4d.	2/6 2½d.
KING & SON'S ditto ...	9d. 3 -	3d.	1/9 2d.
FREMLIN'S MAIDSTONE ALE ...	7½d. 2 6	2½d.	— —
KING & SON'S LIGHT DINNER ALE	7d. 2 6	2½d.	— —

HIGH-CLASS MINERAL WATERS.	Syphons Per doz.	Each	Bottles Per doz.	Splits Per doz.
SODA WATER	3/9	4d.	1/6	1/-
LEMONADE	4/3	4½d.	1/6	1/-
GINGER BEER, &c.	—	—	1/6	1/-
OUR NOTED TONIC WATER ...	5/6	6d.	2/-	1/3

DETAILED PRICE LIST ON APPLICATION.
(Reprint of our List issued circa 1893 - 1906)

Strong Amber Ale: reproduced King & Sons price list. (Author's Collection)

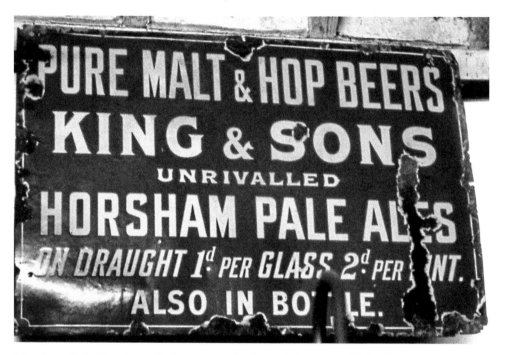

Horsham Pale Ales: King & Sons enamel advert. (Courtesy of John Law)

NORTH STREET BREWERY.

JAMES THORNTON,

Brewer,

NORTH STREET, HORSHAM.

James Thornton, North Street Brewery. (Melville & Co.'s Directory, 1858)

To return to the present, the closure of King & Barnes did not, as first thought, mark the end of five generations of the King family brewing in the town. Their last MD, Bill King, began brewing again as W. J. King in May 2001 on the Jubilee Estate. After a decade of expansion, he sold to businessman Nigel Lambe and brewer Ian Burgess. A further change of ownership in 2013 saw Nikki and Justin Deighton launch their new 'Kings' logo and 'Heritage' and 'Evolution' brands. Beers have recently, however, been produced under the Two Tribes label and UnBarred series, with the King brand discontinued.

Andy Hepworth formed Hepworth & Co. with three other ex-King & Barnes employees. Production began in early 2001 at the Beer Station – a custom-built brewhouse on the railway sidings. Hepworth did not brew its own draught beer until 2003, concentrating until that point on bottling. Thrice winner of the Sussex Drink Producer of the Year award, the company is committed to using local produce and is known for its organic and gluten-free beers. A major expansion took place in 2016 to a new-build site at North Heath.

Former drinks wholesaler Ray Welton started brewing in Surrey in 1995. His mentor in those early days was Fred Martin, retired head brewer at King & Barnes. Brewing ceased in 2000 while Ray focused on retailing. Arundel Brewery contract-brewed the beers until Ray moved his self-built fifteen-barrel plant to Horsham in 2001, sharing the Hepworth site until obtaining his own unit on the Mulberry Trading Estate in 2003. In addition to a regular range, up to 100 individually brewed beers appear each year in a variety of styles to a range of strengths. There are numerous themed beers for football and rugby tournaments and twelve beers of Christmas.

Above left: Five Generations. (Courtesy of Bill King)

Above right: The history of the King family brewing in Horsham. (Courtesy of Bill King)

Brewer Andy Hepworth. (Author's Photograph)

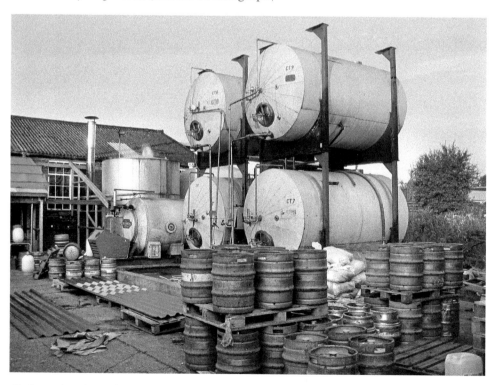

Casks and tanks at the Beer Station of Hepworth & Co. (Brewery History Society Archive)

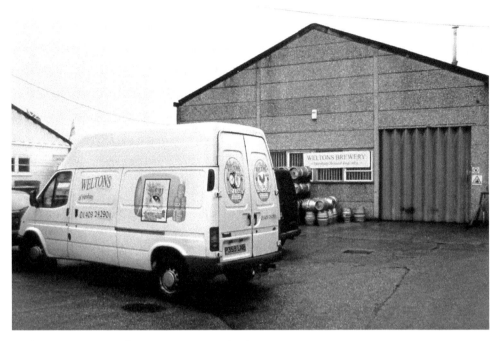

Weltons Brewery and van. (Courtesy of John Law)

Rudgwick

Rudwick Brewery operated commercially from November 2011 to March 2012. Steve Dole produced two casks per brew of a traditional 4.5 per cent bitter, 144 (the number of pints in two firkins) to supply the Sir Roger Tichbourne pub in Alford Bars.

Bill King began brewing again in July 2013 on a ten-barrel plant at the Old Rudgwick Brickworks, joining forces with old friend Richard Peters as Firebird Brewing Co., the name in recognition of the continual regeneration of Bill's brewing heritage. A portfolio of world beer styles is produced.

The world's beers craft brewed in Sussex.
(Author's Collection)

Firebird Beers

We regularly bring out new beers; ranging from local and traditional to international and cutting edge. Here's the current list but it will keep growing!...

Heritage XX Best Bitter 4.0%
Fresh, Hoppy, Full.

Paleface American Pale Ale 5.2%
Zesty, Aromatic, Bold.

Pacific Gem Single NZ Hop Ale 4.2%
Golden, Hoppy, Spicy

Boxing Hare Spring Ale 4.1%
Malty, Pale, Vibrant

Old Ale 4.5% ABV
Smooth, Bittersweet, Luscious

Bohemia Czech Style Pilsner 4.8%
Crisp, Floral, Spicy.

West American Amber Ale 4.7%
Rich, Resinous, Robust

No. 79 Golden Ale 4.3%
Pale, Full, Fruity

Fireweisse Weissbier 5.0%
Crisp, Spicy, Fruity

Full English English Ale 3.8%
Malty, Burnished, Tangy

Saison d'Eté Belgian Style Farmhouse Summer Ale 3.7%
Complex, Fruity, Quenching

Coming Soon...
Belgian Pale Ale, Polish Single Hop, Munich Dark Lager and many more!
See our range and full tasting notes for each beer at www.firebirdbrewing.co.uk

Brewery Shop Now Open!
Visit our shop for brewery fresh draught beers, bottled beers, award winning wines from Taurus Wines, or just to see the brewery in action. We have great gift ideas as well!

Above: Firebird brochure. (Courtesy of Bill King)

Left: Firebird world beers. (Courtesy of Bill King)

Bibliography

Books and Articles

Barber, Norman, *A Century of British Brewers, Plus: 1890-2004*, Brown, Mike and Smith, Ken (eds.), (Longfield: Brewery History Society, 2005).

Cornell, Martyn, *Beer: The Story of the Pint* (London: Headline, 2003).

Hampson, Tim, *Beer Manual* (Sparkford: Haynes, 2013).

Holtham, Peter, 'Malting and Brewing' in Leslie, Kim and Short, Brian (eds.) *An Historical Atlas of Sussex,* (Chichester: Phillimore, 1999).

Holtham, Peter, 'The Brewers of West Sussex' in *Sussex Industrial History*, No. 34, pp. 2–11, 2004.

Holter, Graham, *Sussex Breweries* (Seaford: S. B. Publications, 2001).

Hornsey, Ian Spencer, *A History of Beer and Brewing* (Cambridge: Royal Society of Chemistry, 2003).

Hygate, Nadine, *Wayfarer Denman's Crawley* (Crawley, 1993).

Lemon, Harry, *The Narratives of Miss Selina Worrits* (Crawley: F. Russell, 1866).

Mackey, Ian, *Twenty-Five Years of New British Breweries* (Aylesbury, 1998).

Monckton, Herbert Anthony, *A History of English Ale & Beer* (London: The Bodley Head, 1966).

Peaty, Ian, P., *You Brew Good Ale: A History of Small-Scale Brewing* (Stroud: Sutton, 1997).

Rudkin, David, J., *The Hermitage and the Slipper* (Westbourne, 1974).

Saunders, Pat, 'Henty & Constable Ltd., Westgate Brewery, Chichester' in *Brewery History*, No. 102, pp 65–80, Winter 2000.

Saunders, Pat, 'The Constables of Arundel & Littlehampton' in *Brewery History*, No. 103, pp 4–24, Spring 2001.

Saunders, Pat, 'The Eagle Brewery, Arundel' in *Brewery History*, No. 104, pp 44–53, Summer 2001.

Saunders, Pat, 'Malting & Brewing in St Pancras, Chichester' in *Brewery History*, No. 105, pp 29–49, Autumn 2001.

Saunders, Pat, 'Some Henry & Constable Houses' in *Brewery History*, No. 106, pp 25–37, Winter 2001.

Schnell, Steven M., and Reese, Joseph F., 'Microbreweries as Tools of Local Identity' in *Journal of Cultural Geography*, Vol. 21, No. 1, pp 45–69, Fall/Winter 2003.

Tierney-Jones, Adrian, *Brewing Champions: A History of the International Brewing Awards* (Wolverhampton: BFBi, 2015).

Tombs, Peter, *A Guide to British Brewers: Their Beers and Pubs* (London: Sidgwick & Jackson, 1990).

Weller, Michael, 'Henry Holder: Brewer, Publican and Beer-Seller of Crawley & Horley' in *Sussex Family Historian*, Vol. 6, No. 5, pp 228–231, March 2005.

Wilson, Richard, 'The British Brewing Industry Since 1750' in Protz, Roger and Millns, Tony (eds.) *Called to the Bar* (St Albans: CAMRA, 1992).

Directories

Clarke's Local Directory and Year Book for Mid-Sussex, 1879, 1883, 1884, 1887, 1888.

Deacon's Court Guide: Gazetteer and County Year Book, 1881.

Harrod & Co.'s Postal and Commercial Directory of Sussex, 1867.

Kelly's Directory of Sussex, 1870, 1887, 1911, 1934, 1938.

Melville & Co.'s Directory and Gazetteer of Sussex, 1858.

Pike's Blue Book Horsham, Crawley & District, 1899, 1900.

CAMRA Guides and Newsletters

Good Beer Guide, all editions, 1974–2017.

Sussex Drinker, all issues, 1996–2016.

Websites

Quaffale, Directory of UK Real Ale Breweries, http://www.quaffale.org.uk.

Worthing Pub History, http://worthingpubs.com.